BASEBALL
IN MOBILE

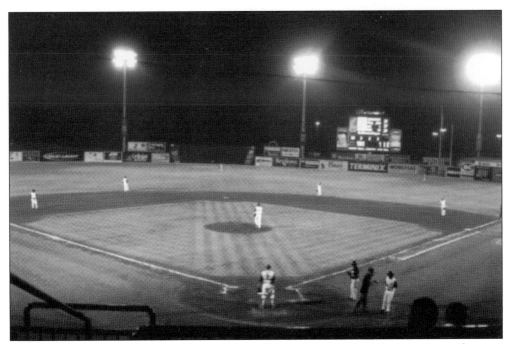

THE BAYBEARS TAKE TO THE FIELD. Selected in a contest, the "BayBears" moniker was created by Betty Woody and chosen by fans as the best name. It incorporates the bay, an integral part of the city, as well as a tip of the hat to the legacy of the original Mobile Bears. (Courtesy of Author's Collection.)

BASEBALL IN MOBILE

To BART —
All the Best,

To BART —
Play ball & best
wishes!
Tamra Hinckle

Joe Cuhaj and Tamra Carraway-Hinckle

ARCADIA

Published by Arcadia Publishing
an imprint of Tempus Publishing Inc.
Charleston SC, Chicago, Portsmouth NH, San Francisco

Printed in Great Britain

Library of Congress Catalog Card Number: 2003110668

For all general information contact Arcadia Publishing at:
Telephone 843-853-2070
Fax 843-853-0044
E-mail sales@arcadiapublishing.com
For customer service and orders:
Toll-Free 1-888-313-2665

Visit us on the internet at http://www.arcadiapublishing.com

CONTENTS

ACKNOWLEDGMENTS

This book contains the past, present, and future of Mobile baseball. Inside are the players, coaches, managers, teams, and the evolving city history that has shaped the sport. While it would have been impossible to include all facets of Mobile baseball within, we have laboriously tried to include the most stirring and historically significant events. Whenever possible, we have included those actually involved in the eras for the most accurate details. Every effort was made to ensure this book was factual, with as many firsthand accounts as possible. Any failure to include significant individuals was unintentional.

Those who were contacted for their assistance in the production of this book provided us with invaluable photographs, anecdotes, and memories. For their overwhelming cooperation and time, we wish to extend our sincere gratitude to Dr. Charles Boyle of Spring Hill College; Bill Shannahan, Tom Nichols, Aaron McCreight, Jason Kirksey, and Jeff Long of the Mobile BayBears Professional Ball Club; Marilyn Culpepper of the Historic Mobile Preservation Society; Cesar S. Lopez, Cuban Baseball Historian; Milt, Frank, and Su Bolling; James Barclay of the Boy Scouts of America, Mobile Area Council; Clyde Hogg; Donnie and Shirley Wagner; Chris Drago; Wayne Hattaway; Felice White; Mr. and Mrs. John Cowart; Buck Williams; Marlon Anderson; Tom Withers; Gloria Aaron; Edward Scott; Kyle McNary; Dr. David Thomas; Alan Wolf; Bill Menton; Mrs. Emmet Mulvey Jr.; Joseph Hudson; Gary Higgenbotham; James Harris Sr.; Eric Yelding; Chris Kitsos; Bill Dardin; Vince Muzik; Chonda Eslava; Denny Wilkins; Regina Cleckler; Skipmilos.com; Mr. Broadway; Ray Thurman; the Mobile Public Library Archives; the Mobile City Archives; Minnesota Twins Media Relations; the Boston Red Sox; University of South Alabama Media Relations; the Philadelphia Phillies; the Vero Beach Dodgers; and Florida State University Media Relations.

In addition to our families, friends, and spouses (a very special thank you, Maggie and Rick), we are grateful for the patience and support of our employer, Adam Systems. Maybe now we can get some work done.

INTRODUCTION

"As surely as the azaleas bloom in the spring, the boys of summer will follow close behind."

Summertime in Mobile, Alabama, consists of mosquitoes, hurricanes, and humidity so thick you can practically carve your initials into the air. The season brings with it summer reading programs at the Mobile Public Library and the scent of brine shrimp wafting off the bay. Lemonade stands sell sweet tea, and at night, the lullaby of the ice cream truck's siren song plays over and over in your head. Hammocks lazily stretch out across vine-entangled porches, where ceiling fans spin into a heat-induced eternity. The mailman wears shorts, the girls wear ponytails, and the men find themselves drawn to seersucker. Picnic hampers are within easy reach and charcoal briquettes top most grocery lists. Road trips are mapped out, while salty bathing suits and cast nets dry on the porch railings. Beaches are moved, little by little, via the floorboards of a million-plus cars. Shrieks of delighted children are heard from blocks away, and grown men find solace from the heat in kiddie pools or, as a decidedly Southern alternative, in the watertight bed of a pickup truck. Like Peter Pan, in summertime, no one wants to grow up.

And in the background is the ever-present ball field. Whether off Satchel Paige Drive or right in your own backyard, it defines summer as nothing else does. It symbolizes late bedtimes, playing catch with dad, and the roar of the crowd. At the ballfield, eyes widen and throats are exposed as heads lift in unison to watch a ball climb higher and higher into the night sky. It is where dreams come true and where you will find, with each passing summer, a sweet slice of nostalgia, thick enough to last all year long.

This book is dedicated to everyone who has stood in the outfield daydreaming.
For those who cannot pitch, cannot throw, and cannot decipher the sign language
of the umpires. It is for those who never got to throw a first pitch and whose time rounding
the bases was only imaginary. It is for those who do the "Wave," sit through rain delays,
and make themselves sick from too many hotdogs. And finally, to those who were
picked last when choosing teams, but who always managed to keep their eye on the ball—
you are who the game is played for. This book is yours.

ONE

Baseball Comes to Mobile
1860–1917

Mobile. Located almost dead center along the Gulf Coast. A 300-year-old port city that has survived the ravages of hurricanes and yellow fever epidemics. It has been passed down from one nation to another, not once, but seven times and was one of the few cities spared during the Civil War.

Mobile has seen its share of history, but none so endearing and legendary as its glorious baseball past. While it seemed at times the flame that ignited the passion of countless Mobilians to take to the diamond would flicker out, it has held on to its legacy and, today, a new generation of ball players are coming out of Mobile.

There is no concrete evidence as to when baseball was first played in the city. The sport, known under countless names—such as Town Ball, Barn Ball, and Round Ball—has been played with different variations of rules since the days of the original 13 colonies.

While the game of baseball spread throughout the country during to the Civil War, Mobile, because of its position as a port city, had already discovered the game. It is known that the game was played on the campus of Spring Hill College along Mobile's Old Shell Road as early as 1860. While the school did not sponsor an official team, we do know that the game was played because of a native Cuban who came to the school to earn a degree. In 1860, brothers Ernest and Nemesio Guillo arrived in Mobile and enrolled in Spring Hill College. After graduation, Nemesio returned to Cuba, but with more than just an education. He also brought the first ever balls and bats. Guillo went on to form the first baseball team on the island, Club Habana, in 1878, and the first league, the Cuban Professional League. Habana won the first six league championships ever held. Guillo, and Mobile, began the baseball craze in Cuba.

Back in Mobile and other parts of the country, baseball was becoming the national pastime, mainly as a result of the formalizing of rules for the game. Many professional teams began to spring up around the city. The first teams were part of the Gulf Baseball League that was formed in 1886 and featured four teams, two from New Orleans and two from Mobile: Club Mobile and the Acid Iron Earth Baseball Club.

There were also many popular semi-pro teams during this time, the most popular being the Mobile Loyals and Stonewalls. The Loyals were literally unbeatable. Between 1897 and 1900, the team trounced area teams handily and traveled to other cities, such as New Orleans, where sell-out crowds watched them play against the local teams.

The site for most of the baseball excitement was Monroe Park. Described as the "Coney Island of the South," the park was located just south of the city along Bay Shell Road. Situated along the banks of Mobile Bay, the atmosphere was electric with a dizzying array of rides, dancing, swimming on the beach, and of course, the ballpark, which sat 6,500 fans.

The first truly professional team, the Mobile Oyster Grabbers of the Southern Interstate League, was organized and played at Monroe Park for only a short single season in 1903. Mobile's next foray into professional ball came quite by accident. The Natchez Indians of the Cotton States League, a "D" class minor league, left Natchez and moved to Mobile to avoid a yellow fever epidemic midway through the 1905 season. The new team became known as the Mobile Sea Gulls-Oystermen. The yellow fever epidemic, however, swept through the South and the season was cancelled after one month. But the team hit the field again in 1906 and, in 1907, earned Mobile its first championship.

This was a team with an identity crisis, changing their name several times. First, they were the Mobile Sea Gulls-Fishermen when the team joined the Southern Association in 1908. One year later, they became the Mobile Reed Birds, and in 1911, they became simply the Sea Gulls.

Major League Baseball enjoyed the warm, sub-tropical climate of Mobile and found the confines of Monroe Park the ideal location to hold spring training. Teams such as the Cleveland Indians, Baltimore Orioles, and Chicago White Sox called the Port City their springtime home.

Attendance at the ballpark skyrocketed to well over 100,000 fans during the 1913 season. In fact, baseball had become so popular in Mobile that city officials sent a petition to the state house and senate requesting that Mobile be spared from a new law that would not allow the game to be played on Sundays in the state. The legislature agreed and, in 1915, Mobile became the only city in the state that was allowed to play the game on Sundays. However by 1917, attendance fell from its high in 1913 down to just over 27,000 for the 1917 season. The manager of the Sea Gulls took matters into his own hands. It was time for a change. Something drastic. Something to grab the attention of the crowds. It was time for another name change.

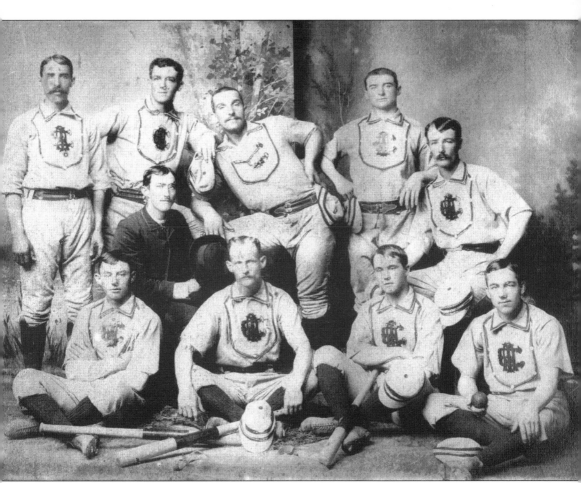

PRO BALL COMES TO TOWN. The first professional baseball teams in Mobile began play during a single season in 1886 in what was called the Gulf Baseball League. There were two teams from New Orleans, Club New Orleans and the Robert E. Lees, and two from Mobile, Club Mobile and the Acid Iron Earth Baseball Club, that played that season. Pictured here is the Acid Iron Earth Baseball Club, named for a locally bottled cure-all tonic made from "nothing but what is contained in the earth." The team was the first from the United States to travel to a foreign country (Cuba) to participate in games with other teams from other nations. The team's manager was "Honest John" Kelly, the great-grandfather of future Mobile Bear batboy Donnie Wagner. The line-up includes, from left to right, (standing) E.M. Davis, J. Wells, E. Cartwright, F. Lewis, and W. Renauld; (seated) E. Duffee, J. Kelly, R. Steinhoff, J. Hayes, and D. Alexander. (Courtesy of Donnie Wagner.)

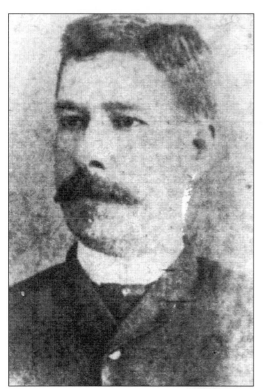

DOUBLE PLAY—MOBILE TO HAVANA.
A native of Cuba, Nemisio Guillo enrolled at Mobile's Spring Hill College with his brother Ernest on May 16, 1860. Nemisio graduated in 1864 and brought back to his homeland not only an education, but also the first baseball bats and balls. He was instrumental in organizing the country's first team, Club Habana, in 1878, and the Cuban Professional League. In the first official game on the island Guillo's Club Habana defeated Club Matanzas 51 to 9 in nine innings (Guillo scored three runs). Habana went on to win six Cuban Professional League championships from 1878 to 1887. (Courtesy of Cesar Lopez, Cubanball.com.)

A BASEBALL TRADITION. The Wagner family has had a hand in Mobile baseball since its earliest days. "Honest John" Kelly was the manager of one of the first teams in Mobile, the Acid Iron Earth Club, in 1886. His great-grandson, Donnie Wagner, was a batboy for the Mobile Bears in the 1940s. Pictured on the left is Donnie Wagner's father, Jessie, with an unknown player on the 1911 Spring Hill College baseball team. (Courtesy of Donnie Wagner.)

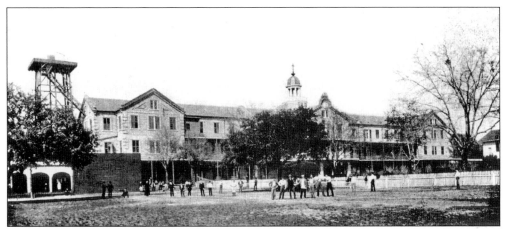

THE "PIT." The Spring Hill College baseball team played on two fields—a smaller junior field and a senior field affectionately known as "The Pit." (Courtesy of Dr. Charles Boyle, Spring Hill College.)

STAN GALLE FIELD. "The Pit" at Spring Hill College is still used today and remains virtually unchanged since the late 1800s. The backstop features the same historic buildings, lined with Mobile brick and draped in a curtain of green ivy. The only change is the field name. While still often referred to as "The Pit," the stadium was officially named "Stan Galle Field" in honor of former Washington Nationals player and Badger coach Stan Galle. (Courtesy of Dr. Charles Boyle, Spring Hill College.)

The World Champion Chicago Cubs came to the Port City on March 22 and 23, 1910. Their first stop was Spring Hill College, where a special day was held in the team's honor, complete with parades and a five-inning exhibition game between the Cubs and the Spring Hill team. Joe Tinker of "Tinker-to-Evers-to-Chance" fame umpired the game. The Cubs won 4-1. Later that night, the Cubs traveled across town to take on the Mobile Reed Birds (formerly the Sea Gulls). (Courtesy of Dr. Charles Boyle, Spring Hill College.)

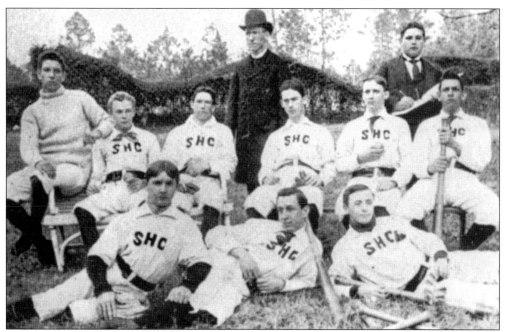

ENTER THE BADGERS. Although baseball was played on the campus of Spring Hill College as early as 1860, the first team to be fielded by Alabama's oldest Catholic college made its debut in 1891. With a lack of area colleges, this early team played local semi-pro ball clubs such as the Mobiles, Crescents, and Dixies. (Courtesy of Dr. Charles Boyle, Spring Hill College.)

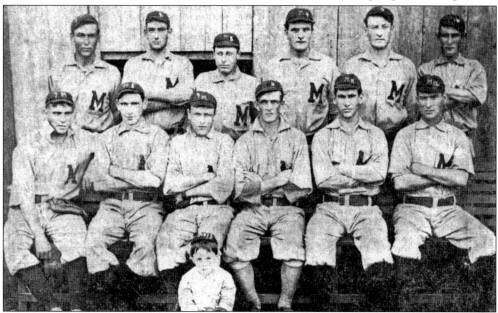

1906 COTTON STATES CHAMPS. Relocated from Natchez, Mississippi, in 1905 due to an outbreak of yellow fever, the Mobile Sea Gull-Oystermen finished first in their division of the Cotton States League in 1906, but lost the postseason cup to Vicksburg. However, the following year, under the management of Bernie McKay, the team rebounded and defeated Vicksburg four games to one to win the championship. (Courtesy of Mobile Library Archives.)

15

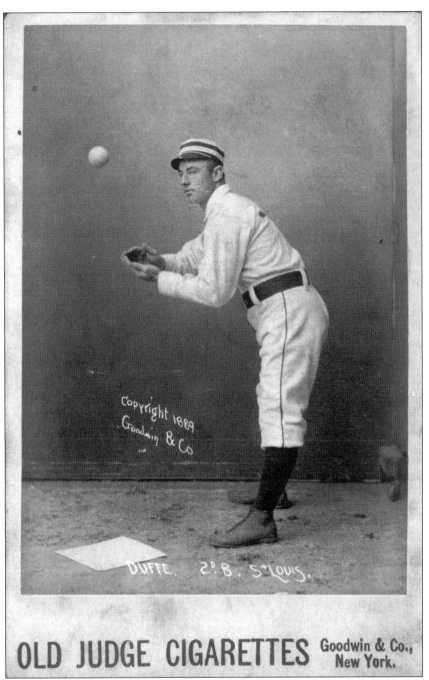

OLD JUDGE CIGARETTES Goodwin & Co., New York.

THERE HAD TO BE A FIRST. Charlie Duffee's career began in 1887 with the Mobile Swamp Angels of the newly formed Southern League. Under the guidance of former Acid Iron manager "Honest John" Kelly, the team earned only fourth place that season, but Duffee, a standout homerun hitter, received the nickname "Homerun." He later went on to become the first player from Mobile and Alabama to go to the majors, playing with the St. Louis Browns from 1889 to 1890, the Columbus Salons in 1891, the Washington Senators in 1892, and the Cincinnati Reds in 1893. (Courtesy of the Author's Collection.)

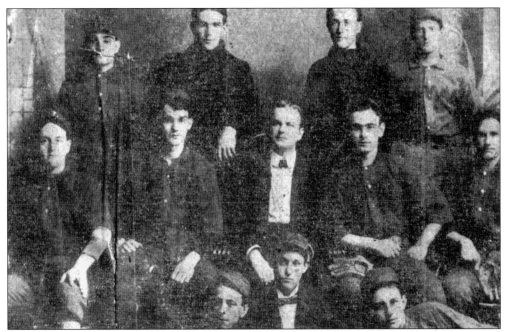

THE UNBEATABLE LOYALS. Between 1887 and 1900, one City League team stood out above the rest—the Mobile Loyals. Managed by William Howard, the team won four pennants. The players would later become the elite businessmen of Mobile, such as third baseman Ernest F. Ladd (future president of Merchants National Bank), who captained the team and was nicknamed "Johnny McGraw." Ed Scheurermann handled first base duties. Known as "the fielding fool," the other players said of their teammate, "Scoop it up and throw it somewhere near Ed. He'll get 'em." When the team was not playing in town, they would visit other cities to play. They were so good that their reputation preceded them and they often found themselves playing before sell-out crowds. (Courtesy of Mobile Library Archives.)

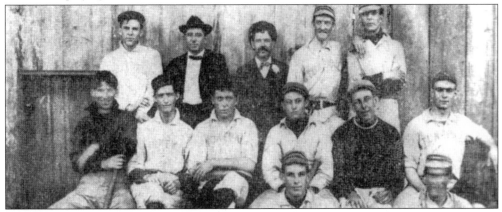

CITY LEAGUE STONEWALLS. In 1899, the early Southern League, to which the Acid Iron Earth team belonged, disbanded, but Mobile's love of the game lived on with the creation of the City League, a group of semi-professional teams including St. Vincent, the Loyals, and one of the best known at the time, the Mobile Stonewalls. The following are pictured in this team photo from left to right: (front row) Emile Fritz and unidentified; (middle row) J.B. Martin, Olice Wernith, Charlie Fritz, and Francis Zieman; (back row) Carl Braun, Dick Blalack, Clarence Blalack, Howard Ruth, and Ed Sherman. (Courtesy of Mobile Library Archives.)

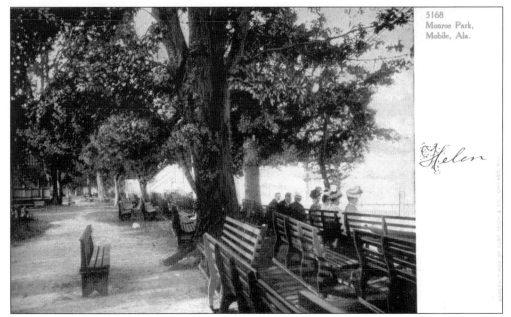

WISH YOU WERE HERE. Once the crown jewel of Mobile, Monroe Park, located south of the intersection of Broad, Washington, and Monroe Streets, exuded both gentility and frivolity. Known as "The Coney Island of the South," the park offered, in addition to its baseball facilities, swimming pools, dance halls, a zoo, and a penny arcade. Its graceful grounds featured wrought iron gazebos, cultivated landscaping, and winding nature pathways. Monroe Park's outdoor movie theater was credited as being the first to show motion pictures in the city. Its waterfront location on temperate Mobile Bay made the park a favorite year-round attraction. (Courtesy of Thomas Miller Collection.)

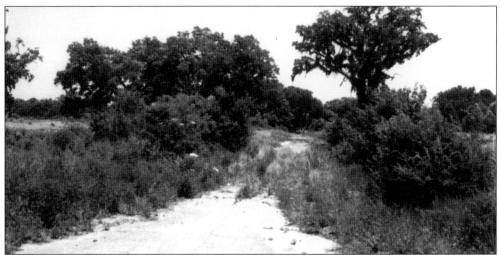

ROAD TO NOWHERE. The outdoor movie screen has long since been torn down, the boardwalk has turned to earth, and the laughter has been stilled. Where carousels once chimed and baseball was languorously played, all that remains of Monroe Park are overgrown fields, mounds of rubble, and the ancient oak trees that have silently watch it all slip away. (Courtesy of Author's Collection.)

18

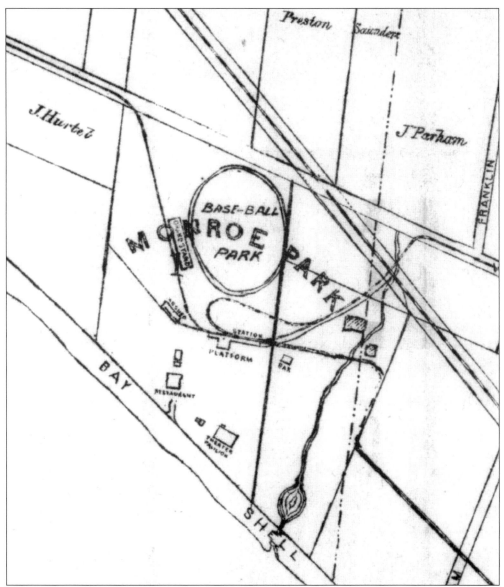

THE PERFECT LOCATION. On this 1901 map, Monroe Park is clearly marked just south of the city along historic Mobile Bay at the junction of Broad and Washington Streets. Several elements made the park special. First, its location along the bay made for the perfect family recreation area, and second, the railroad line that ran directly to the park shuttled thousands of people for an afternoon of summer fun. Also indicated on this map is the bar, restaurant, ball field, grandstand, and theater. (Courtesy of University of Alabama.)

GEORGE EDWARD "RUBE" WADDELL. Famed baseball owner Connie Mack called Waddell the "greatest left hander [he] ever saw." Rube won 24 games and lost only 7 while with the Philadelphia Athletics in 1902. Waddell was a showman—he would wave his teammates off the field and strike out the side. Waddell, knowing he was good and could thereby do as he pleased, often delayed the start of a game while he played marbles with local kids. He came to Mobile in 1908 to make his winter home and to hold out for more money from Connie Mack. Two dispatches were printed in *Sporting Life* of his stay: January 1, 1908, Waddell applied for a political job from Mobile's mayor and February 15, 1908, Waddell is quoted as saying, "Glad to leave Philadelphia where knocker's constantly broke their necks going to Connie Mack every time we looked a drink in the face. Will remain in Mobile until I hear from Connie Mack." His career with Philadelphia was over. (Courtesy of Author's Collection.)

WILLIAM "BABY DOLL" JACOBSON A formidable player in the major leagues from 1915 to 1927, William Jacobson (seen here warming up with players from John McGraw's New York Giants, fourth from the right) earned a nickname for himself at Monroe Park. Jacobson stepped up to bat one day for the Sea Gulls and as he strode to the plate, the band in the stands began playing the song, "Oh, You Beautiful Doll." They continued to play as he took his swing. He knocked the pitch right out of the park and immediately the fans began calling him "Baby Doll." But the hit was special for another reason. While other city's claim the following legend, Mobile seems to have the strongest evidence pointing to the fact that it actually happened in the Port City: Jacobson's ball landed in a freight car bound for New Orleans, thus making it the longest homerun ball ever hit. (Courtesy of Mobile Library Archives.)

20

GULLS AND CRACKERS PLAY IN RECORD TIME

Game at Atlanta, Won by Mobile, Occupies but Thirty-two Minutes and Is Marked by Sensational Work by Both Teams, a Triple Play Being a Feature.

PLAYED ON ITS MERITS.

Other Games on Last Day Prove Farces and Nashville Beats New Orleans and Holds Lead of Second Division.

Pennant Progress

SOUTHERN LEAGUE FINAL STANDING.

Played. Won. Lost. Pc

IN RECORD TIME. On September 17, 1910, the Mobile Reed Birds and Atlanta Crackers played the fastest game on record. It took an incredible 32 minutes to complete the game, which Mobile won 2-1, turning a triple play to boot. The *Mobile Register* laid to rest any doubts about the quality of play in a dispatch from the game, saying, "There was nothing farcical about the game. The players were on the run all the time. Sid Smith was given a handsome watch fob by Atlanta fans. Jordan got a suitcase and club physician Dr. Mitchell, a silk umbrella." (Courtesy of Mobile Library Archives.)

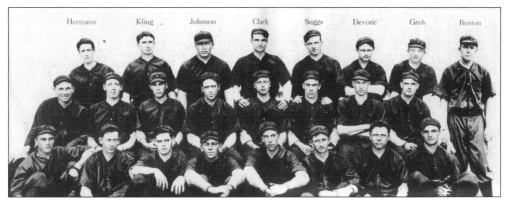

THE DAY THE REDS CAME TO TOWN. On March 11, 1913, the Cincinnati Reds played an exhibition game against the Jesuit team of Mobile's Spring Hill College. The Reds won by a score of 11-3. Accounts of the game related by *The Sporting News* said, "The Spring Hill pitcher threw to the plate. It looked like a strike but the umpire called it a ball. A young lady turned to a priest and said, 'Father, wasn't that one a perfect strike?' To which he answered, 'We of the cloth, my daughter, must be silent umpires, and unbiased, but I think a man who would make such a decision as that is in sore need of a visit to the confessional.'" (Courtesy of Author's Collection.)

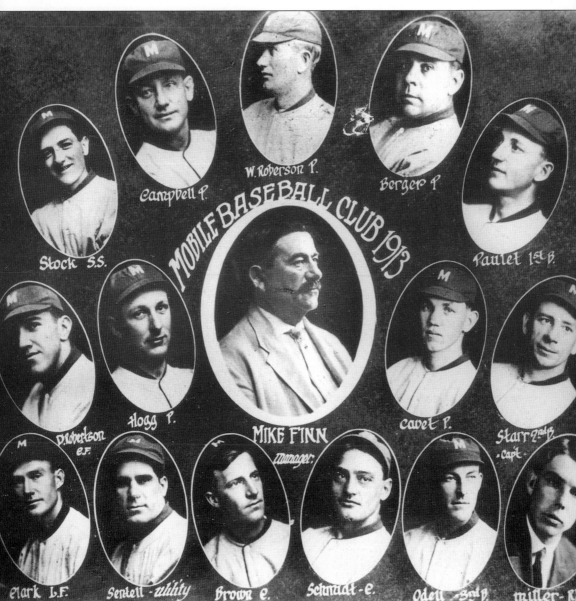

1913 Mobile Sea Gulls. The Mobile Sea Gulls of 1913 finished in second place in the Southern Association and were a huge success with the fans, over 100,000 attending games that season. Managed by Cornelius "Mike" Finn, the team was led on the field by pitcher Tiller "Pug" Cavet with a record of 23 wins and 12 losses. The team's leading hitter was Dee Robertson with a batting average of .335. Other notables on the team included future major leaguers Milt Stock, "Baby Doll" Jacobson, "Hack" Miller, and Brad Hogg. (Courtesy of Clyde Hogg.)

FIRST OF THE LAST SPIT BALLERS.
Bradley Hogg was drafted from the New England League by the Mobile Sea Gulls at the beginning of the 1913 season for $600 and became one of the team's best pitchers over the next three seasons. Known for his spitball, Hogg flirted with the majors, playing for the Boston Braves, Chicago Cubs, and Philadelphia Phillies before becoming the first of the game's spitball hurlers to retire when major league baseball outlawed the pitch. (Courtesy of Clyde Hogg.)

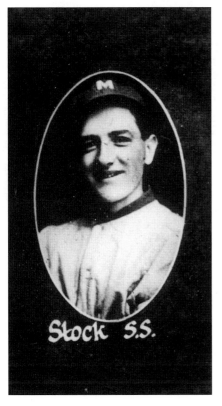

TAKE STOCK. In 1913, Milt Stock was a shortstop with the Mobile Sea Gulls, but late in the season, he made the jump to the big leagues when he was called up for the last seven games of the season to play with John McGraw's New York Giants. In a career that lasted 14 seasons, Stock had a lifetime batting average of .289. He returned to Mobile to take the helm as skipper of the Mobile Bears for the 1926, 1927, and 1928 seasons, but finished no higher than fourth place. The Bears were named the Marines for one season in 1931 when Stock took over as manager, but lack of money and attendance forced the team to move to Knoxville mid-season. They ultimately finished 39.5 games out of first place. (Courtesy of Clyde Hogg.)

23

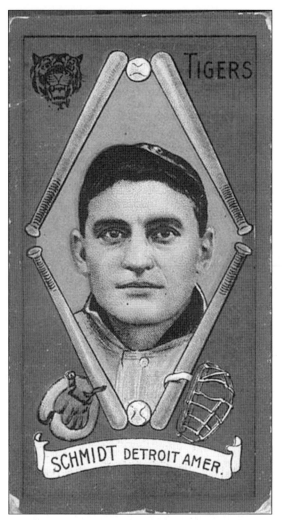

A Dubious Record. Charlie Schmidt came to Mobile in 1915 to manage the Mobile Sea Gulls of the Southern Association. Prior to that, Schmidt was a catcher for the Detroit Tigers. He holds several memorable (and non-memorable) major league records, including committing five errors and allowing 16 stolen bases during a World Series (1909). He is also the only player to make the last out in consecutive World Series (1907 and 1908). An exceptional "brawler," Schmidt earned the nickname "Boss" from his bouts with heavyweight champion Jack Johnson and baseball's Ty Cobb. (Courtesy of Author's Collection.)

1915 Mobile Sea Gulls. These Sea Gulls did not make a splash during the 1915 season. Under manager Charles Schmidt, the team had a losing record of 68-86 and finished 23 games out of first place. The two bright spots on the team were Elmer Miller, who had a team high .326 batting average, and pitcher Brad Hogg who went 22-12. The team played to a crowd of 56,056 that season at Monroe Park. (Courtesy of Author's Collection.)

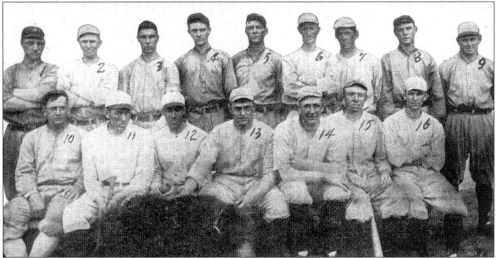

CLUB MILAN. Even though the Mobile Sea Gulls were big business in Mobile, there were many semi-pro teams formed by area businesses that produced some exciting games for fans. Pictured here is one of the many such teams, Club Milan. The origins of the team name and the players have long since been lost. (Courtesy of Author's Collection.)

CROWN THEATER BASEBALL TEAM. Many area businesses sponsored semi-professional ball teams in Mobile in the early 1900s. This is a photo of the Crown Theater team, c. 1916. The Crown's were named for a Crown Theater, a major theater on Dauphin Street in downtown Mobile, which was built in 1907 and originally opened as the Theatorium. (Courtesy of Author's Collection.)

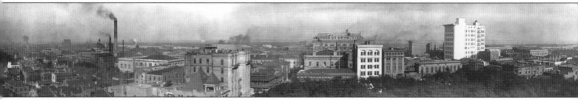

MOBILE SKYLINE, TURN OF THE CENTURY. A rival to New Orleans as the busiest port city along the Gulf Coast, in 1906 Mobile had already survived the perils of her youth. This photograph shows a city fancifully outfitted with towering smokestacks and architecturally rich buildings (many of which are still standing). Though she had already endured French, British, Spanish, and American occupation; the Battle of Mobile Bay; the Civil War and the yellow fever epidemic, her future still held the construction of the Bankhead and Wallace tunnels linking her to the east, the gift of the USS *Alabama* brought to her shore, and a hurricane named Frederick who would sap her strength, but not her spirit. While a grand matriarch at 300, Mobile's debutante days were amongst her finest.

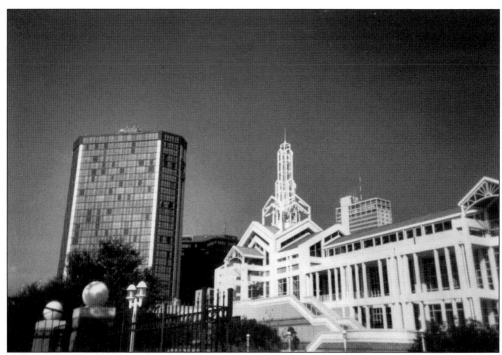

MOBILE SKYLINE, TURN OF THE MILLENNIUM. One hundred years have passed since the top photo was taken. Today, the spires of billowing smokestacks have been replaced with the gleaming white beacon of the Mobile Convention Center along the waterfront. (Courtesy of Author's Collection.)

26

Two

The Glory Years
1918–1961

By 1918, attendance at Mobile Sea Gull games dropped from a high of over 100,000 fans during the 1913 season to a measly 27,121 in the 1917 season. Something needed to be done and Sea Gull manager Pat Flaherty, as owners and managers of the team had done in the past, decided it was time for a change—a name change. The team became the Mobile Bears. "A bear can bite," Patsy told the press. "He can claw, he can hug, and he can fight at the drop of a hat. Sea Gulls don't mean a thing in the world."

Apparently the change worked. A crowd of 5,000 turned out to watch the Bears play New Orleans on opening day at Monroe Park in 1918, the largest one-day crowd in the team's history to that point. The entire city shut down to watch the Bears as they defeated New Orleans by a score of 9-0. Within two years, the team went on to win not only the Southern Association Championship, but also the Dixie Series between the winner of the Southern Association and the champion of the Texas League, the Fort Worth Panthers.

The major leagues continued a presence in the Port City as the Baltimore Orioles held spring training at Monroe Park in 1923 and 1924. Also in 1924, the Yankees came to town with the "Bambino," Babe Ruth, leading the way. The Yanks defeated their farm team from Rochester, New York, in an exhibition game by a score of 8-0.

Life on the Gulf Coast, however, is not always a day at the park, and 1926 saw a hurricane barrel through the city, destroying the bleachers at Monroe Park, and thereby threatening the existence of the team. Mobile mayor Harry Hartwell stepped in. He wanted to build a new ballpark, one that would be a centerpiece for the city's love affair with the game. He convinced city officials to donate a parcel of land at the corner of Tennessee and Ann Streets for this new park. On April 8, 1927, Hartwell Field, named for the mayor, came to life. The event was orchestrated like fine choreography with the city, local businesses, and area schools shutting down for half a day so that everyone had a chance to go to the opening.

The Mobile Bears went through several more transformations over the next few years, both in name changes and relocations. In 1931, the team became known as the Marines and in mid-

season relocated to Knoxville, Tennessee, as the Smokies. In 1932, the Southern League was formed, but it shut down almost immediately due to the Depression; Mobile was granted a new team, the Red Warriors, for the short season. Five years later, in 1937, the Southern League finally got the ball rolling and Mobile fielded another team, the Shippers. The Shippers proved quite successful with appearances in the Little Dixie Series in 1937, 1938, and 1941; they won the 1937 series. World War II put a halt to baseball in the minor leagues, but when it resumed in 1944, the Southern Association's Knoxville Smokies relocated back to Mobile and the Bears were back in business, this time as a farm team of the Brooklyn Dodgers. Their most notable season, the one still talked about today, came in 1947 when they won the Southern League Championship with the likes of "Pistol Pete" Mendorff, Bill Hart, George "Shotgun" Shuba, and future actor, television's "Rifleman," Chuck Connors.

Through all of the changes endured, the fans turned out in droves at Hartwell Field to watch their Bears. Well over 200,000 fans literally crammed into the stadium during the 1947 season. Mobile remained baseball crazed until the mid-1950s, when fan attendance gradually dwindled to become almost non-existent. Money became extremely tight, so much so that during the 1961 season, the team played game-to-game not knowing whether or not they would be paid at the end of the afternoon.

The Southern Association finally made the decision to dissolve the team. Once again, the Bears vanished from the baseball picture and the 1962 season saw Hartwell Field fall silent, this time, with only minor exceptions, for over three decades. The Mobile Press summed the finale up the best: "One of the modern miracles of the ages was the completion of the 1961 season at Hartwell Field . . . Therefore, the end of Mobile in the Southern Association isn't exactly drawing many tears because, unfortunately, not too many people in Mobile care anymore."

The next 36 years found Mobile almost completely devoid of baseball, but the players it spawned during the previous decades were about to become heroes in a big way.

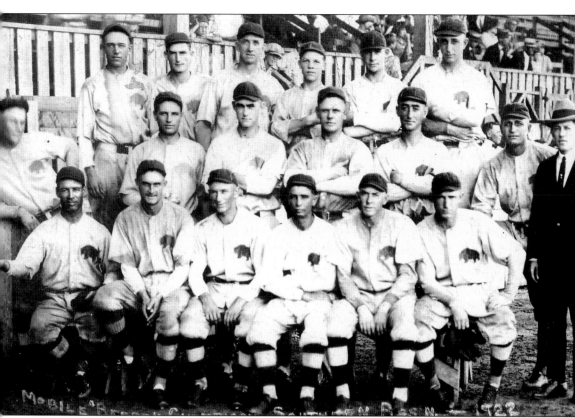

WE ARE THE CHAMPIONS! With a record of 97 wins and 55 losses, the 1922 Mobile Bears won it all that season. Managed by Bert Niefhoff, the Bears played to over 125,000 fans as they won the Southern Association championship and defeated the Fort Worth Panthers of the Texas League for the Dixie Series title. Mobile was so baseball crazy that when the team returned by train, 10,000 fans were waiting at the station and carried the players off on their shoulders. (Courtesy of Mrs. Emmet Mulvey.)

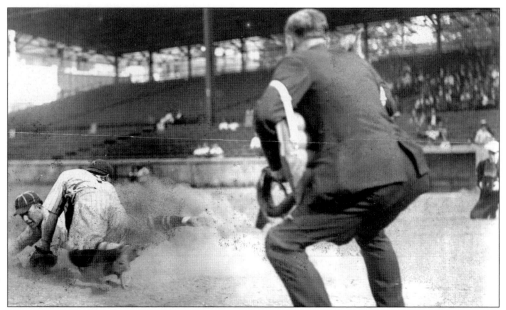

"Never Beaten Until the Last Man was Out." Emmet Mulvey summed up the 1922 Mobile Bears quite nicely with this quote. Not only did the 1922 Bears come through with clutch hitting to win games, but fielding was also instrumental, as seen in this photo of catcher Del Baker making a play at the plate at Hartwell Field. Baker came to Mobile after a career in the majors; he played for the Detroit Tigers from 1914 to 1916. (Courtesy of Mrs. Emmet Mulvey.)

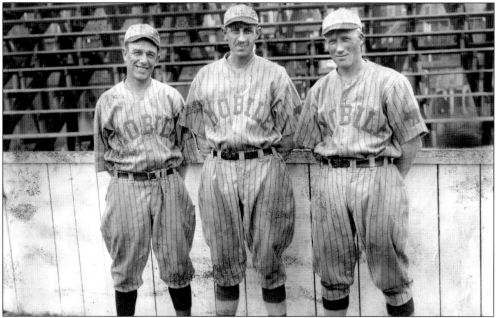

Heroes of 1922. Emmet "Pinch Hit" Mulvey (right) poses in his road uniform with two unidentified players from the 1922 championship Bears. Mulvey described his teammates as "high-spirited and the best ever in the league." They included outfielder Denny Williams, catcher Del Baker, and third baseman Billy Mullen. (Courtesy of Mrs. Emmet Mulvey.)

EMMET "PINCH HIT" MULVEY.
During the Mobile Bears race
to the Dixie Series championship
in 1922, fans never left, even
if the team was down in the
ninth inning, because of one
man—Emmet Mulvey. Time and
time again, Mulvey would get a
game winning hit or homerun.
In his 17 years with Mobile,
Emmet had a career batting
average of .320. (Courtesy of
Mrs. Emmet Mulvey.)

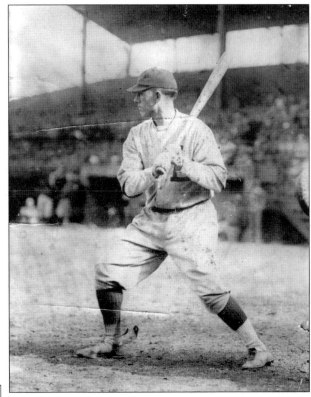

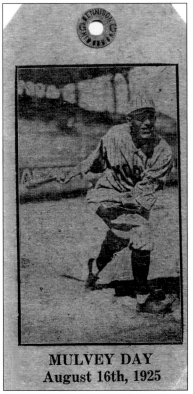

MULVEY DAY
August 16th, 1925

MULVEY DAY. Emmet "Pinch Hit" Mulvey was
such a hero to the city of Mobile during the 1922
championship season that the town organized
"Mulvey Day" on August 16, 1925. Special tags
were sold (pictured here) and donations were made
before the game that day, a sum that totaled $262,
and a gold watch was presented to Mulvey for his
contributions to the team. In typical "Pinch Hit" style,
with the Bears trailing the New Orleans Pelicans in the
bottom of the ninth inning, Mulvey hit a bases loaded
sacrifice fly to win the game for Mobile. (Courtesy of
Mrs. Emmet Mulvey.)

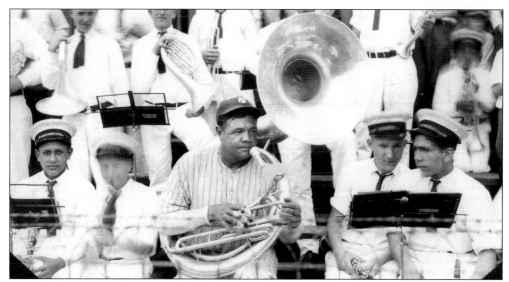

THE BABE. George Herman "Babe" Ruth came to Mobile with the Yankees in 1924 to play an exhibition game with the Yankee's Rochester farm team. On March 31, the Babe paid a visit to Spring Hill College, giving the college team pointers on hitting homeruns and even playing in a pick-up game. Spring Hill pitcher "Puppy" Burguierre put the Babe behind in the count no balls, two strikes. "Puppy" was one pitch away from striking out Ruth, but the Babe had other ideas as he sent the third pitch sailing out of the park, well over 500 feet away. The Yankees then went to Monroe Park (pictured here) to defeat their farm team 8-1. (Courtesy of Dr. Charles Boyle, Spring Hill College.)

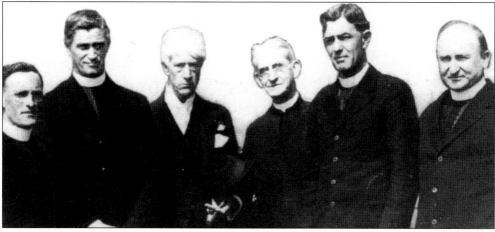

HERE COMES THE JUDGE. Commissioner of baseball Judge Kensaw M. Landis (pictured third from the left), famed for banning the players of the 1919 Chicago "Black Sox," visited Spring Hill College in 1922. Landis was invited to Mobile by mayor Harry Hartwell with telegram that read, "Mobile is Alabama's only seaport, and besides, we have the greatest baseball team in the Southern League." While visiting the campus, Landis was "impressed with the magnificent specimens of Airedales owned by the college." When the next litter of puppies was born, the college sent one to Landis who later wrote back to the college: "He (the Airedale) is the undisputed boss of this establishment, and is a constant reminder of a most delightful visit to your institution and of my intent to inflict myself upon you again next spring." (Courtesy of Dr. Charles Boyle, Spring Hill College.)

MR. ALABAMA BASEBALL. Who was the toughest man to strike out in major league baseball? Mobile's Joe Sewell. For 14 seasons, Sewell was virtually impossible to strike out. Out of the 7,132 games he batted in during his career, he only struck out 114 times. During the 1930 season with Cleveland, Sewell struck out only three times in 353 at bats. In 1933, he did it again, only striking out three times in 503 at bats for the New York Yankees. (Courtesy of Author's Collection.)

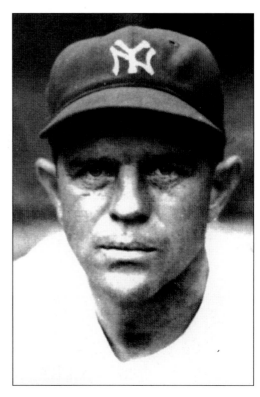

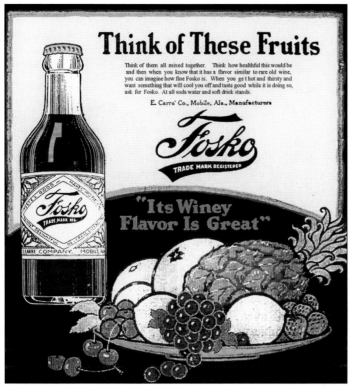

GET YOUR ICE COLD FOSKO! The E. Carre Bottling Company of Mobile was the exclusive soda supplier for the 1927 Mobile Bears baseball team. Their sodas, including Fosko (their biggest seller, distinctive for its "winey" taste), were sold for 10¢ a bottle. You could buy Fosko for 5¢ outside the ballpark, but if you left the ballpark to get a drink, you had to pay 40¢ to get back in. Enterprising hawkers sold peanuts as well, sure to make the thirsty crowd thirstier still. (Courtesy of Denny Wilkins.)

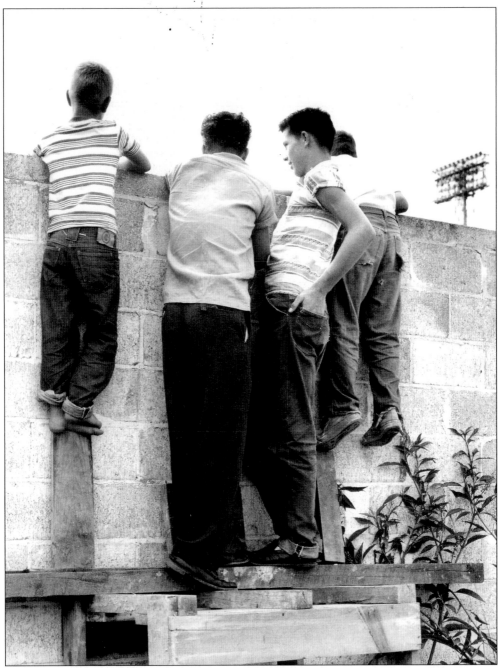

PEERING TOWARDS INFAMY. Watching baseball the old-fashioned way, these boys stand outside Hartwell Field on a makeshift platform, creating a grandstand all their own. Each stadium in Mobile's past has made allowances for "discounted" viewings. The original Hartwell Field had its "Knothole Gang;" the second stadium incarnation, as illustrated here, had its means; and Hank Aaron Stadium pays homage with BayBear Mountain, a man-made hilltop that rises over the field. There, for the mere price of parking, you can take in the game from outside the stadium, and it is a favorite spot for picnicking. (Courtesy City of Mobile Archives.)

HOME AWAY FROM HOME. Originally from Brooklyn, New York, Chris Kitsos came to Mobile in 1955 to play on the Dodgers' farm team. The previous year, Chris had played shortstop with the Chicago Cubs. Kitsos says that several other pros came down to Mobile that year and made the Bears a powerful team, winning not only the Shaughnessy Playoffs and the Southern Association championship, but also the Dixie Series, defeating the Texas League's Shreveport Sports four games to none. (Courtesy of Chris Kitsos.)

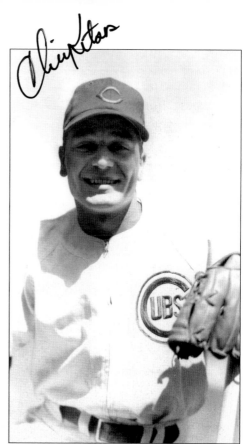

THE MOST FAMOUS BEAR. Whenever someone mentions the history of Mobile baseball, the first name that comes up is Chuck Connors. Best known for his role as television's "The Rifleman," Connors was quite an athlete. After graduating from Seton Hall University, he played basketball for a short time with the Boston Celtics. He then moved on to baseball where he played with the 1947 Mobile Bears, then went to the big leagues and played one game for the Brooklyn Dodgers and then a season with the Chicago Cubs, where he batted .233 in 70 games. (Courtesy of Author's Collection.)

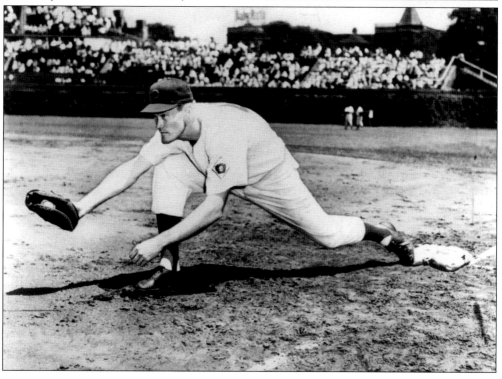

Do We Top 'Em, Or Don't We?
Let's Make Mobile The Talk Of Baseball

Well, this is it, folks.

This is the day when we either do or we don't.

As Mgr. Clay Hopper told the Lions Club members the [other] day, he'll take care of those Pels out there on the field. [It's u]p to us to show the rest of the world what kind of base[ball] town we're living in.

Atlanta has come out with a flat prediction of 12,000 for [the] opener in the Georgia capital. Other cities in the loop [are v]arying up to 10,000, the number expected by the ticket committee in New Orleans. The rest of the league is [expect]ing our charm city to [...]

[tab]le along with about 9000, they think is going to be good for Mobile.

not less than 1500 colored fans out for the game, and they probably will have their own colored

MAWNIN'. One of the most popular columns in the 1940s *Mobile Register* was "Mawnin'" by Buzz Walker. The city looked to Buzz for the "buzz" on baseball around Mobile, from the city leagues to the Mobile Bears. Buzz often stirred the hornet's nest with fellow writers from other cities, touting Mobile as the "best baseball town." Walker was all over the city watching games and, on a few occasions, his observations of local players would land the players a contract. (Courtesy of the Mobile Library Archives.)

INVITATION TO THE DANCE. In the 1940s, getting signed to minor league baseball was a bit easier than it is today. Buzz Walker, writer of the column "Mawnin'" in the *Mobile Register*, spoke highly of a local player, Donald "Lefty" Burnett in one of his articles. A few days later, the owner of the 1945 Bears, Edgar C. Allen, wrote a letter requesting that "Lefty" try out with the team. (Courtesy of Mobile Library Archives.)

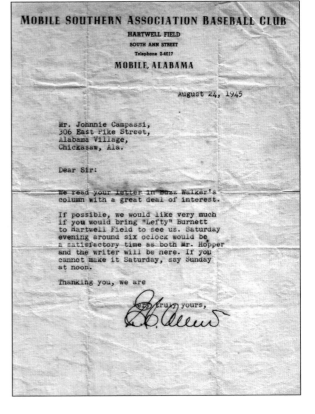

THE END RESULT. As you can see in this photo, a little letter writing goes a long way. After the tryout with Allen and his Mobile Bears, "Lefty" Burnett was signed to a contract with the Bears for the whopping sum of $250 per month. One clause of the contract is the "Loyalty Clause," which states that the player "pledges himself to the American public to conform to high standards of personal conduct, fair play, and good sportsmanship." (Courtesy of Regina Cleckler.)

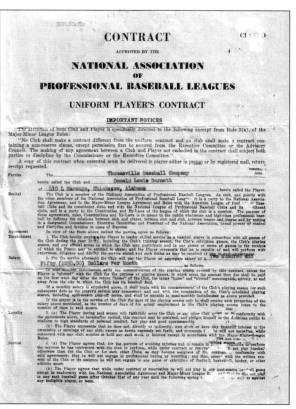

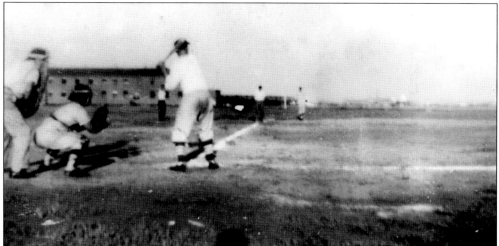

DOING THEIR PART. During World War II, minor league baseball was shut down so the players could do their part for the war effort. Many joined the service, while others went to work in the factories. In Mobile, a special "Industrial League" was established so the city would have entertainment during those tough times. Two divisions were created, the Industrial Division with teams from the Alcoa aluminum factory, Alabama Ship Yard, and Gulf Ship Yard and the Service Division, made up of players in military service from Brookley Air Base, Barin Field, and the United States Coast Guard. Pictured here is "Lefty" Burnett, formerly with the Bears, later with the Chicago Cubs, at bat with the Brookley team. (Courtesy of Regina Cleckler.)

MOBILE BEARS 1944 OFFICIAL SCORE BOOK. During the war effort, everyone did their part for the nation's best interest and baseball was no exception. Excerpted from within, this scorebook proudly reads, "Baseball in 1944 is on a patriotic mission; to furnish, after working hours, millions of American workers with happy, healthful relaxation. Baseball can justly be proud of this worthwhile contribution to winning the war." (Courtesy of Mr. Broadway.)

"BUY ME SOME PEANUTS AND CRACKER JACKS." While baseball has always nourished a hungry soul, there are often times when something a little less rhetorical, and a little more caloric, is needed. Published inside this 1945 Mobile Bears scorebook are concession stand advertisements, sure to get anyone through the dinner-hour games. Hotdogs were priced at 10¢, while a pack of cigarettes or cup of beer would set you back a quarter. (Courtesy of Mr. Broadway.)

KEEPING UP WITH THE BEARS.
Sportscaster Bill Menton was famous for his coverage of the Mobile Bears games. Included inside this 1946 scorebook is the advertisement inviting listeners to tune into his "Sportslite" show that aired at 6:45 Monday through Saturday on station WMOB. (Courtesy of Mr. Broadway.)

HARTWELL FIELD ADMISSION PRICES.
In addition to low concession prices, the admission price guide printed in this 1947 Bears scorebook guaranteed the sound value of a night at the park. Grandstand adult admission was $1.10, but if you wanted to sit on the bleachers, you were only charged 75¢. Ladies Night offered a discounted price of 35¢ for the female patrons. Parking across the street was 15¢ per automobile. (Courtesy of Mr. Broadway.)

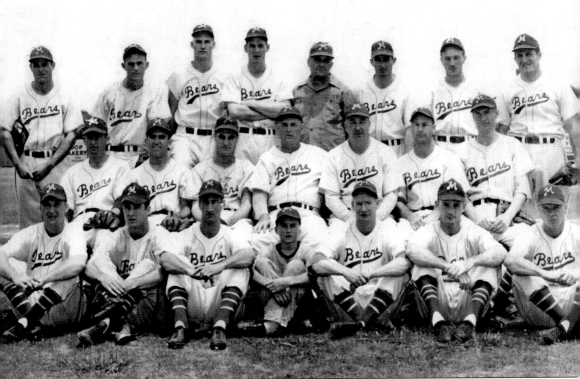

THE BEST-LOVED BEARS. To this day, the city of Mobile fondly remembers the 1947 Mobile Bears. The players were part of the family. Some say that if George "Shotgun" Shuba had run for mayor, he would have won in a landslide. The team finished the 1947 season with a record of 94-59, sweeping eight straight games in the Shaughnessy Playoffs to take the Southern Association title, only to lose four games to two to Houston in the Dixie Series. Pictured from left to right are (front row) John Sosh, John Hall, Calvin Abrams, batboy Donnie Wagner, Roy Boles, Roy Whitaker, and William Hart; (middle row) Joe Powers, Stan Wasiak, Homer Matney, coach William Rollings, manager Al Todd, Harold Younghans, and E.M. McGlothin; (back row) Cliff Dapper, Frank Laga, Chuck Connors, Paul Minner, trainer Ralph "Doc" Kelly, Willis Maupin, George Shuba, and Pershing Mondorff. (Courtesy of Donnie Wagner.)

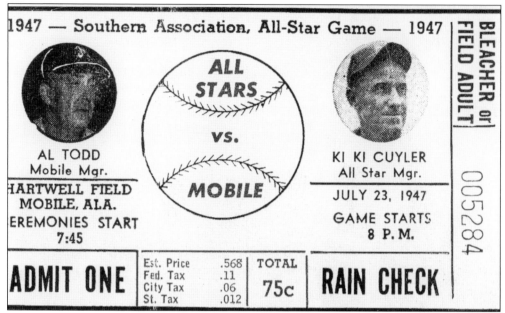

1947 SOUTHERN ASSOCIATION ALL-STAR GAME. On July 23, 1947, the Southern Association held its All-Star Game at Mobile's Hartwell Field. Each year the team that was in first place halfway through the season, in this case the Mobile Bears, would take on the All-Stars. The Bears continued to dominate the league after the All-Star break and won the 1947 championship. (Courtesy of Chris Drago.)

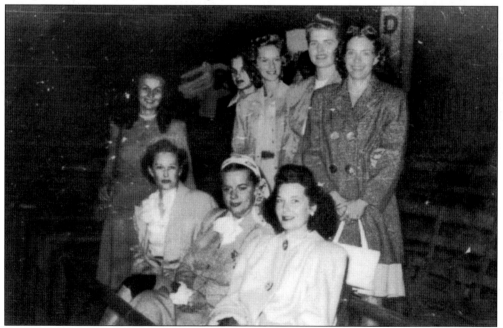

PLAYERS' WIVES. In a time when any self-respecting lady wore gloves and lipstick before setting foot out the door, the wives of the 1946 Mobile Bears players, pictured here at Hartwell Field, were no exceptions. Beautifully groomed and elegantly attired, they represented a most gracious and charming cheering section. (Courtesy of Felice White.)

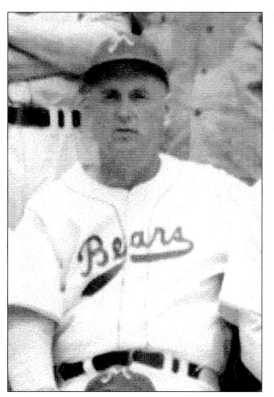

COACH WILLIAM ROLLINGS. Mobile native William Russell "Red" Rollings hit the major leagues at the age of 24, playing first, second, and third bases for the Boston Red Sox in 1927 and 1928 and for the Boston Braves in 1930. He was the assistant coach to manager Al Todd with the Mobile Bears in the late 1940s. (Courtesy of Buck Williams.)

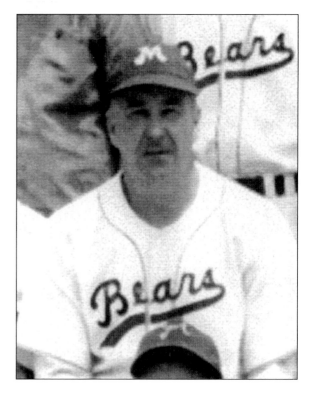

MANAGER AL TODD. The manager of the Mobile Bears from 1946 to 1948, Todd led the Bears to a record of 244 wins and 212 losses. From 1934 to 1943, Al was a catcher for the Philadelphia Phillies, Pittsburgh Pirates, Brooklyn Dodgers, and Chicago Cubs. He led the National League in RBIs in 1937 with 86. (Courtesy of Buck Williams.)

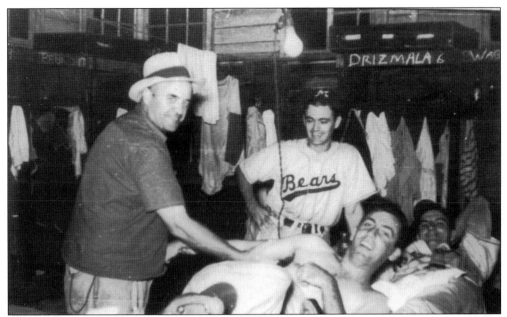

"Doc" Kelly. A mainstay in the Mobile Bears clubhouse from 1944, when the Bears were reestablished in the Southern Association, until the 1950s, Ralph "Doc" Kelly was the steady team trainer. He is pictured here, *c.* 1948, working on pitcher Joe Smolko while unidentified team members watch. (Courtesy of Felice White.)

You Make the Call. Harry Chosen, catcher for the 1945 Mobile Bears, set the Southern Association record for the longest consecutive hitting streak. Another player set the original mark at 45 straight games in 1925. After hitting in 30 straight games, Chosen walked once in his bid for his 31st game and then was hit in the head with a bat while catching in the same game, forcing him to retire for the night. After sitting out a number of games, Chosen made a comeback and returned to the league hitting in 16 straight games immediately upon his return. The league decided that he technically didn't finish the last game he was in before leaving, so Chosen was credited with setting the new record at 49. (Courtesy of Chris Drago.)

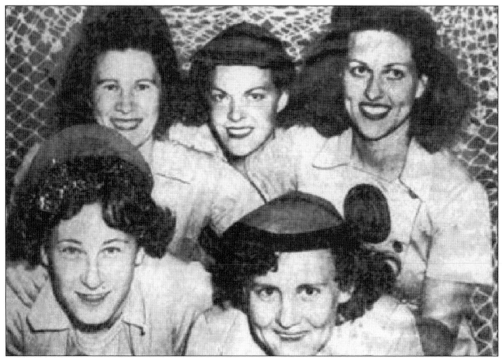

A ROCKFORD PEACH. Mobile's own Marge Holgerson (pictured bottom right) joined the All-American Girls Professional Baseball League in 1947 and became a left fielder for the Rockford Peaches. She played in the league until 1952; she was married during her career and became Margaret Silvestri. The following are also pictured from left to right: (front row) shortstop Snooke Harrell and Marge Holgerson; (back row) pitchers Olive Little, Carolyn Morris, and Verna Wilson. (Courtesy of Author's Collection.)

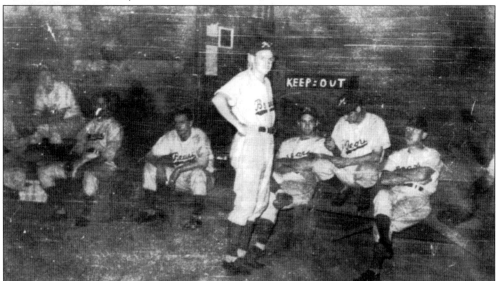

BEHIND THE SCENES. This photo offers a rare glimpse into the Mobile Bears' clubhouse at Hartwell Field, *c.* 1949. Joe Smolko stands while other members of the team relax prior to game time. (Courtesy of Felice White.)

GEORGE "SHOTGUN" SHUBA. A powerful and popular outfielder for the Mobile Bears from 1945 to 1949, Shuba set the batting mark for the team many times, including in 1948 when he batted .389 and in 1949 when he hit .328 with 28 homeruns (many through the windows of the pulley factory across the street from Hartwell Field). He split his 1948 season with the Bears and Brooklyn Dodgers, making the permanent move in the 1949 season. In seven years with the Dodgers, Shuba hit .259 with 24 homeruns in 814 at bats. (Courtesy of Donnie Wagner.)

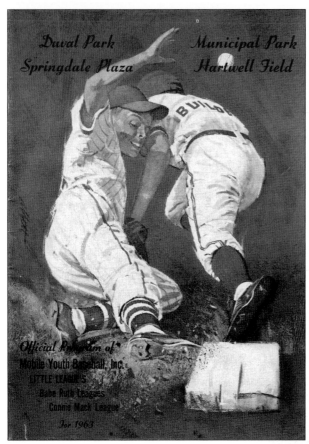

THE MANY USES OF HARTWELL FIELD. The friendly confines of Hartwell Field were not only limited to professional baseball. On any given night when the field was not being used by the Bears, any number of different events might be taking place, including football games, boxing, and youth baseball. Pictured here is a program from the 1963 Youth Baseball season featuring teams from the city's Connie Mack and Babe Ruth Little League. The teams also used Municipal Park in west Mobile and a ball field that is now Springdale Mall. (Courtesy of Chris Drago.)

THE TRADITION CONTINUES. From his great-grandfather, "Honest John" Kelly, who managed one of the first professional teams in Mobile in 1886, to his father who played ball for the Spring Hill College team, a young Donnie Wagner continued the baseball tradition when he was presented to the owner of the Bears by team trainer Doc Kelly to be the team's batboy in 1945. Donnie says the camaraderie of the team was phenomenal, like family, and that spilled over into the city that still talks about the great 1947 Mobile Bears. Wagner made many lifelong friends from the team including Stan Wasiak and George Shuba. (Courtesy of Donnie Wagner.)

"HE WAS A CHARACTER." That is how friends remember Wayne Hattaway. Wayne's career in baseball began as a batboy with the 1952 Mobile Bears. He stayed with the team until they folded in 1961, but was hired as a trainer for the first New York Mets farm team who played their spring training at Hartwell. Following that season, Wayne was hired by the Minnesota Twins organization, where he did the bus tour with their various farm teams. Every time the bus would cross into Alabama in the middle of the night, Wayne would wake the team by yelling, "Wake up boys! You don't want to miss this!" (Courtesy of Buck Williams.)

50-PLUS YEARS AND COUNTING. Wayne continued working his way up the ladder and is now the clubhouse manager for the Minnesota Twins. The stories of his journeys could fill a book, and so could his sayings. While working with the Birmingham Barons, a farm team for the Chicago White Sox, the players would hang around the clubhouse long after a game was over, keeping Wayne from finishing his work. To get them to leave, he would say, "The money ain't here, boys. It's in Chicago." (Courtesy of the Minnesota Twins.)

47

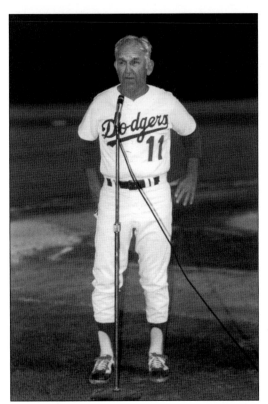

"KING OF THE MINORS." Known by some as "The King of the Minors" or, to those who knew him better, as "The Whistler" for his incessant whistling on the field, Stan Wasiak made a career in the minors, bringing up some of the best players of the day. During his early playing days in the late 1940s, he manned second base for the Mobile Bears, including the 1947 championship team, while working at the Alabama State Docks during the off season. But the Dodgers, the Bears' parent organization, was grooming another second baseman to move up—Jackie Robinson. "How could a Polish boy from Chicago take the place of the greatest player I ever saw?" Wasiak said, and he took a job with the Dodgers managing their Valdosta farm team in 1950. He continued managing in the minors until 1986 when he retired from the Vero Beach Dodgers with the record for most wins by a minor league manager of 2,561. Following his death, the Vero Beach Dodgers dedicated their executive office building to the "King." (Courtesy of the Vero Beach Dodgers.)

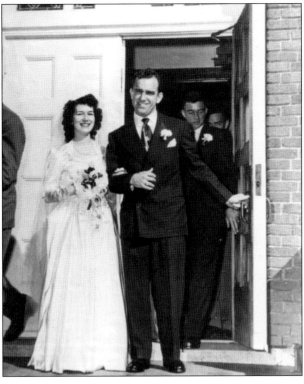

THE KING TAKES A QUEEN. Stan Wasiak and his new bride, Barbara, emerge from the chapel on their wedding day. In later years, Wasiak was crowned "King of the Minors," a credit to his 37 years as a minor league manager and the subsequent 2,570 victories amassed during that time. Both a player and manager for the Mobile Bears, Stan was inducted into the Mobile Sports Hall of Fame in 1987. (Courtesy of Donnie Wagner.)

NO ORDINARY JOE. A formidable pitcher for the Bears in the late 1940s, Joseph "Joe" Smolko led the team in pitching several times, including the 1948 season when he won 20 and lost only three. That performance helped put the Bears into the Shaugnessy Playoffs of the Southern Association once again, only to lose to Nashville four games to three. (Courtesy of Felice White.)

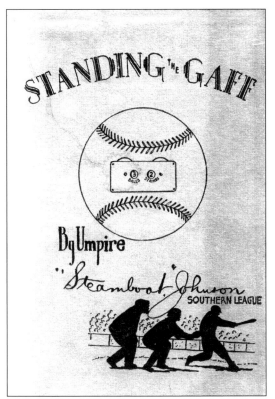

STANDING THE GAFF. In 1935, Southern Association umpire Harry "Steamboat" Johnson wrote this memoir of "life as a minor league umpire." Johnson carried boxes of the book with him as he traveled the South from city to city, selling them to the crowd prior to the games he was umpiring. A story that Johnson told was that one day he came to Mobile to officiate a game, as always he arrived and sold books to the gathering crowd at Hartwell Field, but during the game, Johnson made what the fans thought was a bad call against the Bears and they threw thousands of copies of his book at him from the stands. Johnson turned to the batboy and yelled, "Pick 'em up! I'll sell 'em in Memphis!" (Courtesy of Chris Drago.)

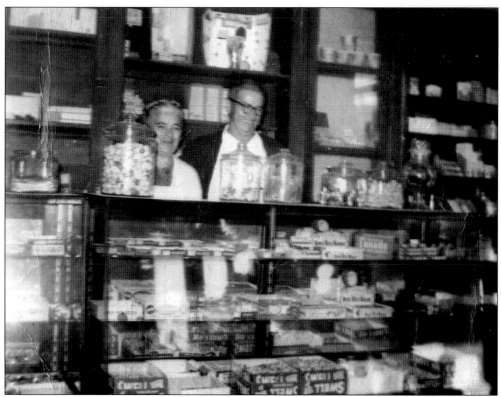

SWEETS FOR THE SWEET. A candy and ice cream shop owned by the Rigas family was located at the corner of Ann and Tennessee Streets. An integral part of the community, the owners sponsored a city league team, the Rigas All-Stars (pictured below). As a way of promotion during the games, the store would make and distribute tiny nougat candies, shaped in the form of a baseball, to patrons at Hartwell Field. (Both images courtesy of Mr. and Mrs. John Cowart.)

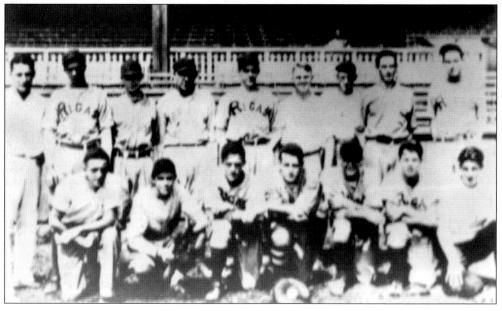

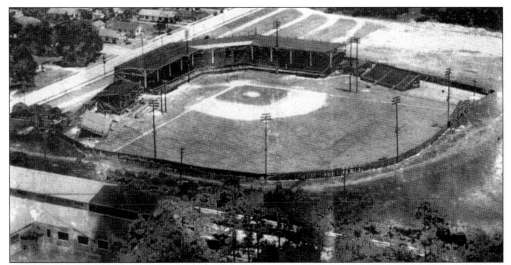

A BIRD'S EYE VIEW. This photograph offers a rare glimpse of Hartwell Field from the air in the 1940s. The field was originally built in 1927 and was named for the Mobile mayor Harry Hartwell who put the plans into motion to build the stadium. In 1958, the stadium was remodeled and it was torn down in 1983. The street running across the upper left corner is Ann Street. In the bottom left corner is the Mobile Pulley and Machine Works factory on Tennessee Street that saw many windows busted out by homerun balls. (Courtesy of Chris Drago.)

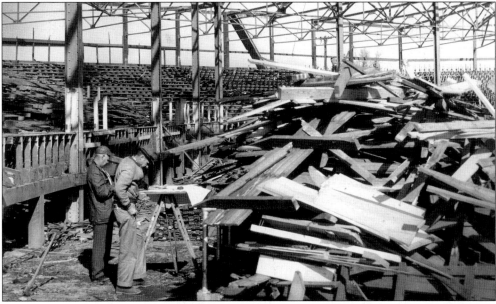

AND THE WALLS CAME TUMBLING DOWN. In 1958 Hartwell Field was condemned, being deemed too dangerous to seat fans. Despite declining fan attendance and revenue, the city decided to renovate the stadium. The project, which began with a price tag of $400,000, quickly ran to well over $1 million and was touted in the newspapers as "a white elephant." Construction ran late with the team not playing at home until late May and night games were not played until June. In only two years, professional baseball would leave Hartwell Field, and except for occasional high school baseball and football games, the stadium proved the press right. (Courtesy of Mobile City Archives.)

51

HOUSE OF MIRTH. Located at 1221 Texas Street, the former Eastburn Boarding House served as home away from home for several Mobile Bears players. Within walking distance to the stadium, the house was the site of many foolish pranks at the hands of the young players housed within. The innkeepers, Charles and Sally Eastburn, gladly served as surrogate parents to the boisterous men in their charge. Mrs. Eastburn was a renowned cook; several fond memories remain of her sweet iced tea being served from a huge pickle jar, her mountainous bowls of mashed potatoes, and of her lemon icebox pie, a personal favorite of 1947 pitcher John Hall, who believed eating an entire pie before the game was his good luck charm. (Courtesy of Author's Collection.)

BIG LEAGUES. BIG BUSINESS. Ever since baseball began in Mobile, the major leagues loved to come to town to play exhibition games in the spring. In this 1955 clipping from the *Mobile Register*, the Cleveland Indians were planning to play the New York Giants at Hartwell Field. Though the grandstands were segregated, the ad touts the appearance of Willie Mays as the big draw. (Courtesy of Mobile City Archives.)

PROMOTIONS OF THE 1950s. They did not have the Famous Chicken or the Blues Brothers, nor did they give away tee shirts; in the 1950s, the fans came solely to the fields because they loved the game. The time between innings was spent talking to neighbors, making new acquaintances, ragging the umpire, or just enjoying the concessions. One of the rare giveaways was simple enough—the pocket schedule. It was also available at most stores around town. (Courtesy of Chris Drago.)

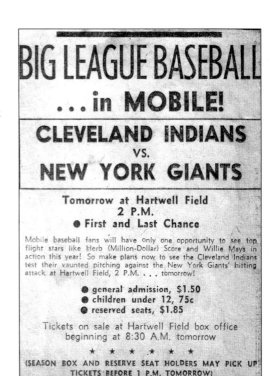

BIG LEAGUE BASEBALL
... in MOBILE!

CLEVELAND INDIANS
VS.
NEW YORK GIANTS

Tomorrow at Hartwell Field
2 P.M.
● First and Last Chance

Mobile baseball fans will have only one opportunity to see top flight stars like Herb (Million-Dollar) Score and Willie Mays in action this year! So make plans now to see the Cleveland Indians test their vaunted pitching against the New York Giants' hitting attack at Hartwell Field, 2 P.M. . . . tomorrow!

● general admission, $1.50
● children under 12, 75c
● reserved seats, $1.85

Tickets on sale at Hartwell Field box office beginning at 8:30 A.M. tomorrow

★ ★ ★ ★ ★ ★

(SEASON BOX AND RESERVE SEAT HOLDERS MAY PICK UP TICKETS BEFORE 1 P.M. TOMORROW)

Official
BASEBALL
SCHEDULE

MOBILE
Bears

1955

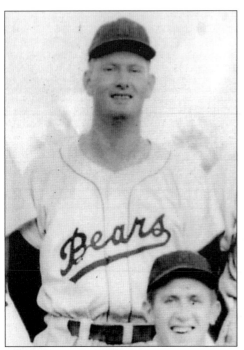

A LOVE OF THE GAME. Bill Dardin saw his first professional game as a youngster at Hartwell Field. It was a Mobile Shipper's game. Bill, awed by what was happening on the field and the skill the players mastered, never looked back until he became a pitcher and signed to play for the Dodgers' organization. He eventually returned to Mobile and Hartwell in 1956 as a Bear's pitcher for manager Jo-Jo White. (Courtesy of Bill Dardin.)

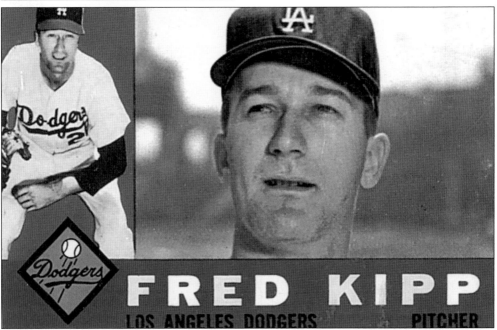

FRED KIPP. Fred Kipp was signed by the Dodgers in 1953 and was assigned to the Vero Beach Dodgers, where he won 15 games, had an ERA of 2.23, and a batting average of .343—not bad for a pitcher. Kipp fulfilled military duty from 1954 until 1955 when he came to Mobile to play with the Bears for 10 games at the end of the season. During that time, he pitched an ERA of 2.34, helping propel the Bears to yet another Southern Association title and, eventually, the Dixie Series title after they defeated the Shreveport Sports four games to none. (Courtesy of Author's Collection.)

54

"POPEYE." Don Zimmer, pictured in this 1955 team photo of the Brooklyn Dodgers, sits to the right of Dodger and Bears teammate George Shuba. Those who played with Zimmer on the Bears' teams of the early 1950s say that Zimmer had a laid back attitude about his performance. For example, he may go 0-4 in a game and then 0-3 in the next, but around the dinner table at the Eastburn boarding house on Texas Street, he would lean back his chair and lazily say, "Boys, the cream will rise to the top." After a storied career with the Dodgers, Zimmer took to managing the great Boston teams of the mid-70s and is currently assistant coach to Joe Torre and the New York Yankees. (Courtesy of Donnie Wagner.)

WADE BROWNING. Pictured here with the St. Paul's Episcopal High School Team, a team that produced such notable players as Norm Larker, is Wade Browning. Wade became a standout pitcher for the Mobile Bears and the Southern Association in 1952, with a league-leading ERA of 2.80, winning 14 games in the process. Wade fell just short of the majors and retired in 1960 with the Dodgers farm team in Montreal. (Courtesy of Buck Williams.)

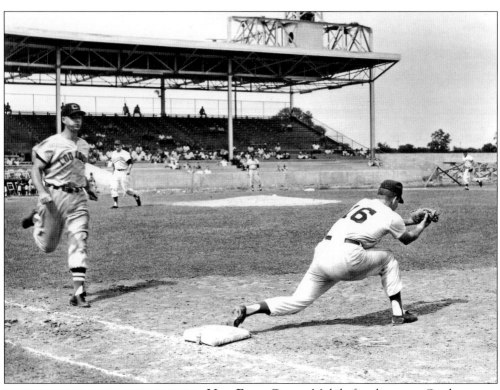

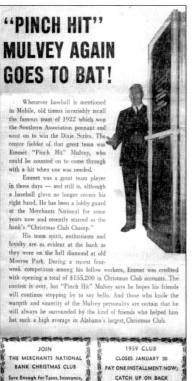

NOT EVEN CLOSE. Mobile first baseman Gordon Coleman makes it look easy as he gets out this batter from the Chattanooga Lookouts in a game at Hartwell Field in 1956. Coleman left Mobile, and in 1959 he played with the Cleveland Indians, then he played 8 seasons with the Cincinnati Reds before he retired in 1968. (Courtesy of Mobile City Archives.)

"PINCH HIT" MULVEY AGAIN GOES TO BAT!

Whenever baseball is mentioned in Mobile, old timers invariably recall the famous team of 1922 which won the Southern Association pennant and went on to win the Dixie Series. The center fielder of that great team was Emmet "Pinch Hit" Mulvey, who could be counted on to come through with a hit when one was needed.

Emmet was a great team player in those days — and still is, although a baseball glove no longer covers his right hand. He has been a lobby guard at the Merchants National for some years now and recently starred as the bank's "Christmas Club Champ."

His team spirit, enthusiasm and loyalty are as evident at the bank as they were on the ball diamond at old Monroe Park. During a recent four-week competition among his fellow workers, Emmet was credited with opening a total of $155,200 in Christmas Club accounts. The contest is over, but "Pinch Hit" Mulvey says he hopes his friends will continue stopping by to say hello. And those who know the warmth and sincerity of the Mulvey personality are certain that he will always be surrounded by the kind of friends who helped him bat such a high average in Alabama's largest Christmas Club.

| JOIN THE MERCHANTS NATIONAL BANK CHRISTMAS CLUB Save Enough for Taxes, Insurance, Gifts and Other Year-end Expenses | 1959 CLUB CLOSES JANUARY 30 PAY ONE INSTALLMENT NOW; CATCH UP ON BACK PAYMENTS LATER |

A HIT ON AND OFF THE FIELD. Twenty years after his heroics on the field for the 1922 Mobile Bears, Emmet "Pinch Hit" Mulvey was still fondly remembered by the city and became a pitcher of sorts, pitching the advantages of a Christmas club account with Merchant's National Bank in this 1954 advertisement from the *Mobile Register*. (Courtesy of Mrs. Emmet Mulvey.)

THREE

LeRoy "Satchel" Paige and the Negro Leagues

Baseballs thrown into the air in Mobile backyards can often be lost in the whiteness of magnolias in full bloom. It is a distraction—like a magician, his assistant and the sleight of hand you never see coming. The birds certainly did not. As a child, LeRoy Paige would practice throwing at these moveable objects—perfecting his aim, calculating his target's response. Most of the time, like his future pitches, his opponent never knew what hit him, and the bird would fall to earth, unaware and silent. Surely this must have startled LeRoy, looking at his hands, his arm in disbelief and then, the slow realization of the power that lie within would wash over him like rain. That same power carried him into the Hall of Fame over 60 years later.

Born and raised in Mobile, a teenaged LeRoy took a job at Union Station, where, as a porter who earned 10¢ per bag, he devised a way of carrying several suitcases (or satchels, as they were called) at once. The other porters noted he looked like a "walking satchel tree" and the moniker "Satchel" stuck. Playing ball on his day off was a diversion, a pastime. In Mobile in the 1920s, with segregation and the murky past of a town where slavery had been a way of life, there was not much else to do. Facilities for dining, theaters, schools, restrooms, and water fountains were all clearly labeled for separate races and baseball was no exception.

Rube Foster founded the Negro National Baseball League in 1920. Shortly thereafter, a minor circuit for Negro players developed in the south. Though a notch below the big city leagues, the Southern Negro League boasted of having some of the finest players in the South. In the spring of 1926 during spring training exercises, Alex Herman, a former acquaintance from Mobile and a player/manager for the Chattanooga Black Lookouts, rediscovered Satchel's pitching talent and signed him to the team for a stipend of $50 per month (part of which was sent directly to Satchel's mother—a small reward for allowing her 18 year old son to be taken out of state). From there, he went from team to team, pitching in over 2,000 games during the 1930s and 1940s—his arm was golden, his attitude cocky. According to the Negro League, "the black press found his humor quotable, and his flamboyant manner and good natured braggery made for entertaining newspaper copy. Negro baseball had in Satchel Paige the rare asset that

Babe Ruth had been for the white major leagues—a humorous, colorful, engaging bragger with a child-like personality, who just happened to be able to justify his boasts on the playing field. When had any pitcher been so outrageously arrogant and taunting as to send the infield to the dugout while he faced the best hitters in the opposition lineup?"

The Negro Leagues flourished, but with the sweet, came the bitter. When white ball clubs traveled the country, spending nights in local hotels, the Negro player was forced to stay in rooming houses, usually located on the outskirts of town. When the white ballplayer was paid upwards of $40,000 per year, the Negro player usually garnered only an average of $2 per game. But to the fans of black baseball, the players were role models, and the Negro League ball teams played to full stands. The game represented a respite from economic and social troubles, an event where the community gathered to cheer on that which was wholly theirs.

The white spectator was also drawn to the Negro league games often by the flamboyant comedy routines performed by the players before the first pitch was thrown; while several expressed that it did the game of Negro ball a disservice by making a mockery of the athletes, it drew the curious, and indeed, kept them there long enough to see that those performing on the field before them were much more than comedians. There was Josh Gibson, one of the greatest distance hitters of all time, who hit between 60 and 70 homeruns per season and was known as the "Black Babe Ruth." There was James Thomas (aka "Cool Papa Bell") who was noted for his super-sonic speed and thereby proclaimed, "The fastest man in baseball." There was a Mobilian nicknamed "Pork Chops" (reportedly because that was all he ate on the road), better known as Henry Aaron, who, in 1974, broke Babe Ruth's home run record. There was Ted "Double Duty" Radcliffe and his brother, Alex, both from Mobile. The former was to become the oldest major league ball player on the roster at the age of 96 in 1999 and the latter was acclaimed as "The best third baseman in Negro American League history." David "Showboat" Thomas, who was regarded by some as the best fielding first baseman the Negro Leagues ever produced, and Bobby Robinson, known as the "Human Vacuum" for his ability to snag any ball coming in his general direction, rounded out the list of Mobile natives.

In 1947, Mobile had a successful semi-pro team, the Black Shippers (later, the name changed to the Black Bears). Managed by Jim Harris, who is considered the father of baseball in black communities throughout Mobile, and coached by Jesse Thomas, who later went on to sign Willie McCovey to the San Francisco Giants, the Black Bears played at Hartwell Field, with its segregated bleachers, when the white teams were on the road. When the white teams returned, the Black Bears would take off on barnstorming tours, playing against the greats of the Negro American League teams. While on tour throughout the southern cities, the Black Bears often encountered Jim Crow laws, the legal, though unethical, system of discrimination against African Americans. For them, food was served only at the "back door" of restaurants and gas station attendants refused them admittance to the restrooms. When Jackie Robinson and Roy Campanella arrived in Mobile for an exhibition game between the Atlanta Braves and Brooklyn Dodgers at Hartwell Field in 1954, they too were forced to stay in a boarding house, as opposed to staying in the same hotel with the rest of their teammates.

Still, it was the love of the game that both brought and kept the players in the Negro Leagues, regardless of the shameful conditions. Even on his trips home to Mobile, Satchel Paige played pick up games with fellow Negro Leaguer Ralph Donahue; some said those games lasted all day into early twilight with the score 0-0. It had nothing to do with recognition, but everything to do with the power, the ability, and the honor of playing baseball.

Rube Foster, meanwhile, relentlessly lobbied the National Baseball Commissioner, Judge Kenesaw Landis, for play between the Negro League and major league stars. Though Judge Landis never publicly commented, it was commonly perceived knowledge that he, along with several major league baseball team owners and managers, was determined to keep the league segregated.

Though little changed initially, time moved on and the racial injustice of disallowing African Americans to play grew increasingly loud. With the advent of civil rights came Jackie

Robinson, hired in 1947 by Branch Rickey, general manager of the Brooklyn Dodgers, as the first African American major league baseball player. Chosen for his intellect and integrity, he withstood the abuse rained down on him, and silently went to work at a job he loved to do—playing ball. Baseball changed completely as he took to the field; while thunderous voices were heard in the stands, one man stood against another, a pitch was delivered and history was made. Everything baseball stood for—grace, elegance, and class—was defined that day. Finally, the sport was what it was supposed to be: the best competing against the best, regardless of the color of their skin.

At the age of 42, Satchel Paige became the oldest rookie in major league baseball; he played for the Cleveland Indians in 1948 and continued on to win 28 games over a six-year career. When questioned as to whether or not he was in prime shape to compete against the younger athletes, Satchel responded, "All I have to do to get my arm in shape is shake hands with the catcher." Where Jackie Robinson was quiet elegance and statuesque dignity, Satchel was swaggering bravado and self-assured showmanship. Still, according to the Negro League:

> White newspapers were reluctant to recognize or report the existence of black baseball and few performances by a black player, no matter how impressive, were sufficient to gain the attention of a press dedicated to the proposition of separate but equal. However, by virtue of his tremendous pitching talent and ability to defeat the best that the white major leaguers had to offer, Satchel Paige was cast as the rebel who challenged the claimed superiority of major league baseball. His boastings taunted the white fan to buy a ticket to see his boasts tested. In this respect, Satchel has been credited as a catalyst for the ultimate integration of the major leagues, and his showmanship was the vehicle that carried the black ballplayer out of the obscurity of segregation and into the national spotlight."

With his debut as the first black pitcher of the American League, his appearance drew the largest crowd ever (78,382) to attend a night game.

With the rise of blacks admitted to and thriving in the majors, the Negro Leagues were faltering; African Americans had turned their attentions to major league ball, to cheer on their own that had risen to the top. Though the Negro leagues were the largest black owned commercial enterprise in America in the 1940s, the NBL league quietly folded in 1961, due to waning interest and financial difficulties. After surviving segregation, the depression, war, and discrimination, the league closed the door on a legacy that has far outlived it.

After beginning his pitching career with the Mobile Tigers in 1924, LeRoy "Satchel" Paige retired in 1965, at the age of 59. After a career spanning five decades and garnering him the title of "Greatest Pitcher in the History of the Negro League," the first Negro League inductee into the National Baseball Hall of Fame, and various MVP honors, Satchel still humbly claimed, "I ain't ever had a job. I just always played baseball." Known not only for his pitching, but also for his confidence and astute words, he left behind an epitaph carved on his tombstone that spoke for the sum of his accomplishments and certainly, of things yet to come: "Don't look back—something might be gaining on you."

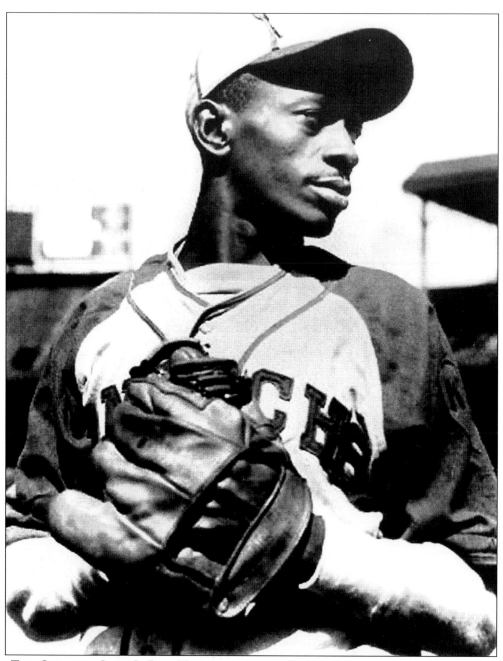

THE ONE AND ONLY LEROY "SATCHEL" PAIGE. Pitching great and contemporary Dizzy Dean once said of Paige's tremendous pitching ability, "Let 'em argue. The best pitcher I ever seen is ol' Satchel Paige. My fastball looks like a change of pace alongside that li'l pistol bullet Satch shoots up to the plate." Indeed, to prove just how true his aim was, Satchel would often replace home plate with a bottle cap in order to showcase his control of the ball. (Courtesy of Author's Collection.)

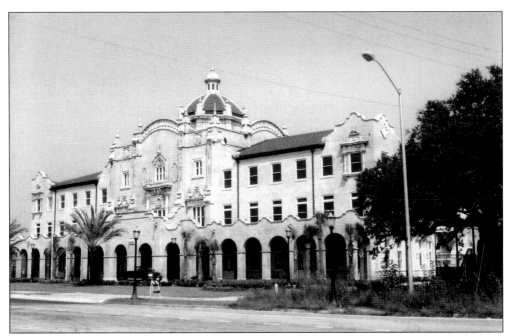

STILL STANDING. Built in 1907 and recently refurbished at the cost of $19 million, the GM&O (Gulf, Mobile and Ohio) railroad terminal regally stands in the heart of downtown Mobile. The GM&O passenger hub, also referred to as Union Station at one time, is where LeRoy Paige received his nickname, "Satchel," a nod to the time he spent there as a porter. (Courtesy of Author's Collection.)

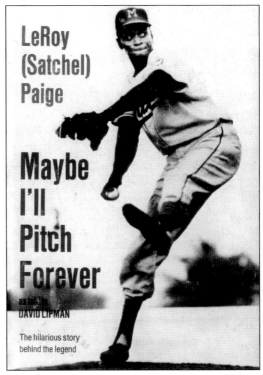

MAYBE I'LL PITCH FOREVER. Satchel Paige's autobiography, *Maybe I'll Pitch Forever*, originally published in 1962, was widely acclaimed. Reviewed as "colorful, spirited, conversational, and immodest," the book places the reader in Paige's size 12 shoes as he recounts his life in baseball. On being named oldest major league rookie at the age of 42, came Satchel's widely renowned reply: "Age is a question of mind over matter. If you don't mind, it don't matter." (Courtesy of Chris Drago.)

61

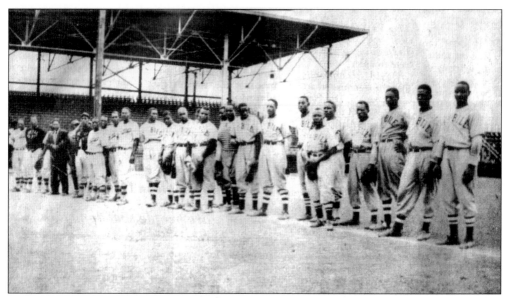

MOBILE BLACK SHIPPERS. As with all Negro League teams of the period, the Mobile Black Shippers garnered their name from the city's white team, the Mobile Shippers. The Black Shippers, like the Black Bears in years to come, were extremely popular. Many of the names are now lost in history, but pictured here from right to left are Clarence Durette, Ollie Young, "Bo" Payton, manager Jesse Thomas, Clifford Blackmon, Melza Crews, and "Wrist" Williams. (Courtesy of Chris Drago.)

Black Bears Win 6 Games On Tour

Mobile's Black Bears, Colored Southern League baseball team, won six out of eight games in a tour of points in Florida in which such strong opposition as the Dr. Pepper nine of Pensacola and a fast St. Petersburg were met.

Colored Bears' hurlers Nathan Owens, Harry Simpson and Martin Crews furnished a winning brand of mound work while on the tour.

Vertis "Midnight" Thomas and Robinson Morgan were poison at the plate against the best pitching offered by opposing teams.

The Black Bears are scheduled to open league play Thursday against the Nashville outfit of the Colored Southern League.

5 in 5 innings (none out in 6th): Mueller; 1 in 4. Balk. Wilson. Losing pitcher, Wilson. Umpires, Rue, Boyer and Summers. Time, 1:40. Attendance, 3,294.

BLACK BEARS NEWS. The Mobile Black Bears made a rare appearance in the 1945 *Mobile Register*. Because of segregation, information regarding Negro sports was rarely considered newsworthy. Not only confined to the sports section, African Americans found that within the entire paper, they were not given the courtesy titles of "Miss" or "Mr." that were afforded to the Caucasian residents. (Courtesy of Mobile Library Archives.)

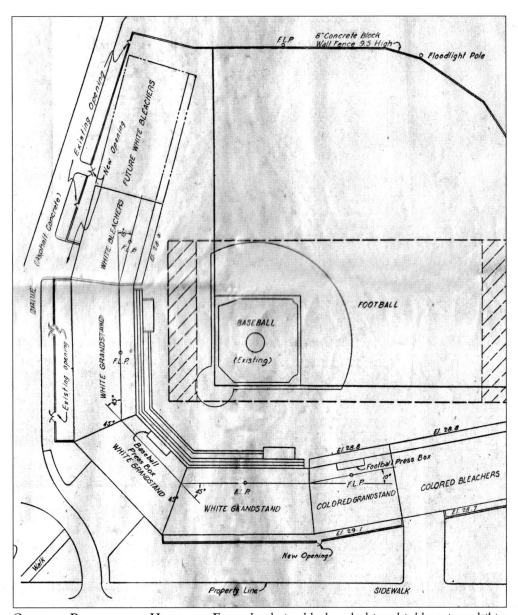

ORIGINAL BLUEPRINT OF HARTWELL FIELD. In glaring black and white, this blueprint exhibits the separation of the races. Note the size of the "White Grandstand" section on the left hand side compared to the "Colored Bleachers" at the bottom. (Courtesy Mobile City Archives.)

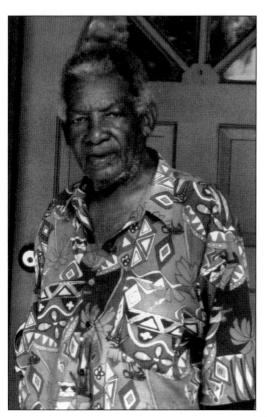

THE FATHER OF MOBILE BLACK BASEBALL. Well into his 80s, Jim Harris looks back on his days as manager and player for the Mobile Black Bears and Black Shippers with fondness. Considered the "Father of Black Baseball" in Mobile, Jim helped bring up many of the greats from the city. He recalls that the great Negro League teams of the day would barnstorm into Mobile where the Black Bears and Black Shippers would quickly route such notable players as "Double Duty" Radcliffe and "Showboat" Thomas. In a city and time when the line between the black and white populations was crystal clear, Harris says that on the south side of Government Street, the line was erased and integration was an afterthought. Many times on the local ball fields a sandlot game of major league proportions would take place with the great Mobile players, black and white, playing in a then unheard of interracial pickup game. In that event, Mobile was ahead of its time. (Courtesy of Author's Collection.)

DAVID "SHOWBOAT" THOMAS. As a player and manager for the Ethiopian Clowns, Thomas once led his team to victory during a tournament with a hard fought ninth inning save in which they scored six runs. During a ceremony after the game, the master of ceremonies thanked Thomas by saying, "Showboat, I want to tell you that the folk in this town think your boys are swell. Not only are you great ballplayers, but we, who have dealt with you through this tournament, know you as gentlemen and sportsmen." In response, Showboat said, "Thank you, and I want to say that means as much as does our winning the tournament." (Courtesy of Kyle McNary.)

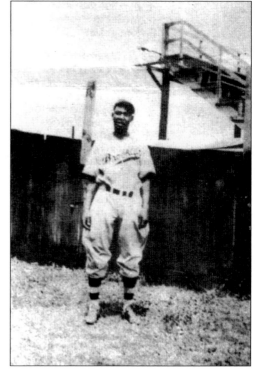

BOBBY ROBINSON. Born in Whistler in 1903, Will "Bobby" Robinson was known as the "Human Vacuum" for his ability to snag any ball coming in his general direction. Signed at the age of 14 with the semi-professional Pensacola Giants, Bobby was considered one of the best third basemen of his generation. (Courtesy of Kyle McNary.)

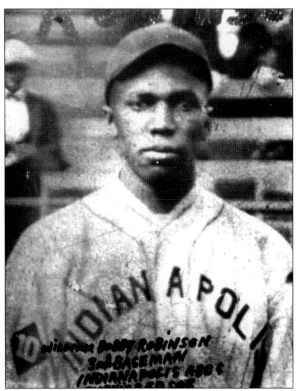

THEODORE ROOSEVELT "DOUBLE DUTY" RADCLIFFE. Mobile-born "Double Duty" was named for his dual star catching and pitching abilities. Throughout his career, Radcliffe exercised an entrepreneurial spirit, often forming All-Star teams of Negro League players for the purpose of independently booking exhibition games against white major league players. Often, Satchel Paige was Radcliffe's business partner in these highly successful ventures. Beginning his career in the Negro Leagues in 1920, at 101 years old "Double Duty" remains the oldest surviving Negro League player. (Courtesy of Mobile Library Archives.)

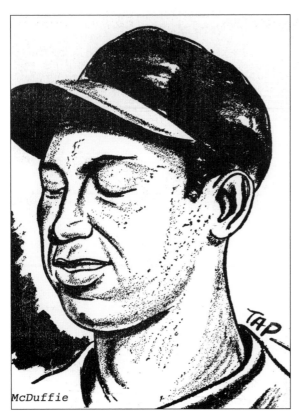

McDuffie

DODGERS TRYOUTS. Prior to the major league's signing of Jackie Robinson, Mobile natives Terris "Speed" McDuffie and Dave "Showboat" Thomas, at the urging of three African American sports editors prominent in their demands for major league integration, tried out for spots on the Brooklyn Dodgers 1945 team. While surprised at the unexpected appearance, the Brooklyn managers relented to a tryout with general manager Branch Rickey the next day. While uneventful, McDuffie's control was rated "very good" and Thomas' report read, "He showed power," the event itself was significant as it prompted an agreement that baseball should establish a committee on integration. Six months later, Jackie Robinson was signed to the Dodgers farm club, the Montreal Royals. (Courtesy of Kyle McNary.)

"SHOWBOAT" A "NO-SHOW" ON SUNDAYS. According to his great nephew, Dr. David Thomas, David "Showboat" Thomas and his brother, Jesse Thomas, were, at one time, ousted from attending church by their Sunday school superintendent brother because they played baseball on Sunday. For years, Mobile was the only city in the state of Alabama that played on the Sabbath. (Courtesy of Kyle McNary.)

PRINCES AMONG MEN.
Teammate and Mobilian George Shuba meets Jackie Robinson at home plate on the day of his debut with the Montreal Royals, just after his inaugural homerun. Here, in the spring of 1946, Jackie's influence in American baseball was only just beginning. Less than a year later, Jackie Robinson would emerge as the first African American major league baseball player on the Brooklyn Dodgers team. (Courtesy of Donnie Wagner.)

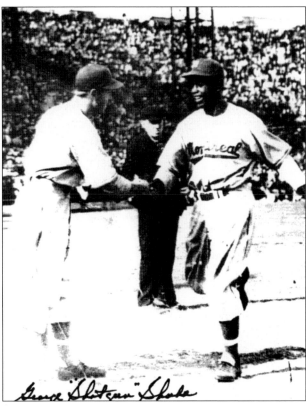

NEGRO AMERICAN LEAGUE WORLD SERIES OF 1952. Pictured is a letter from Syd Pollock, general manager of the Indianapolis Clowns of the Negro American League, requesting scout Ed Scott secure Hartwell Field for a "World Series" between his Indianapolis Clowns and the Birmingham Black Barons. The tone of the letter suggests that management at the stadium was not receptive to the idea; Pollack stresses that he "works very closely with the Brooklyn Dodger's chain" (the Bears were a farm team of the franchise). The game was played on September 27, 1952, and was touted as "Hank Aaron Day." Hank returned to Mobile to play with Indianapolis that day, making it his first professional game in Mobile after playing with the Clowns and then with the Eau Claire team. The newspaper article that appeared the day of the event mentioned that a "special grandstand will be reserved for white patrons," a turnaround at the time. The winner of the game was not reported in the paper. (Courtesy of Edward Scott.)

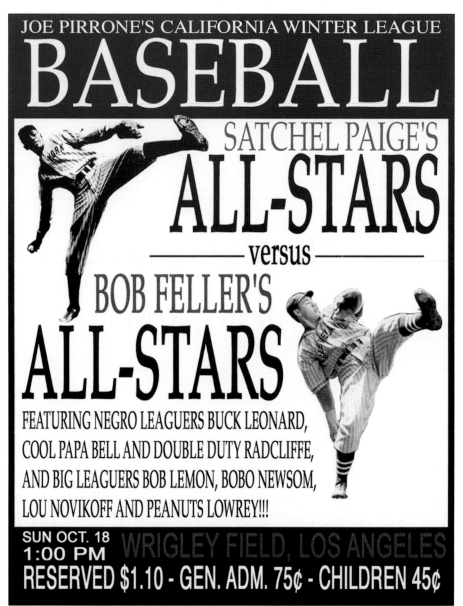

JOE PIRRONE'S CALIFORNIA WINTER LEAGUE

BASEBALL

SATCHEL PAIGE'S
ALL-STARS
—— versus ——
BOB FELLER'S
ALL-STARS
FEATURING NEGRO LEAGUERS BUCK LEONARD,
COOL PAPA BELL AND DOUBLE DUTY RADCLIFFE,
AND BIG LEAGUERS BOB LEMON, BOBO NEWSOM,
LOU NOVIKOFF AND PEANUTS LOWREY!!!

SUN OCT. 18
1:00 PM WRIGLEY FIELD, LOS ANGELES
RESERVED $1.10 - GEN. ADM. 75¢ - CHILDREN 45¢

HOW ALAN WOLF BECAME KNOWN AS "LITTLE SATCH." Alan Wolf, a Negro League player from Mobile, was part of the Satchel Paige All-Stars. Though bearing his name, Satchel himself rarely made it to any games. The team played other pitchers wearing Satchel's uniform and few knew the difference. The last day of the tour found the team in Miami. They had used all of their pitchers, so they decided to move Wolf from second base to the mound for the final game. He threw a few to the opposing team when a man in the stands stood and yelled, "Throw the heat, Satch!" The catcher ran to the mound and told Wolf to play it up because the crowd believed he was Satchel. No one had realized that Paige wasn't there. About that time, the catcher told him to throw his "famous" hesitation pitch. Wolf wound up and threw. His hat went one way, his glove the other, he fell to the ground, and the ball trickled off the field. The man in the stands yelled out, "That man isn't Satchel!" and the team had to run for their lives to get out of town as the fans stormed the field. (Courtesy of Kyle McNary.)

68

FOUR

The Fabulous
Bolling Brothers

There is a difference between celebrity and distinction. Celebrity is glamour, paparazzi, and sunglasses. Distinction is marked by ability, respect, and admiration—for more than memorizing lines and pretending to be someone else.

There are two retired major league ballplayers from Mobile whose genetic predisposition for baseball came easily. Nephews of Jack Bolling, they are brothers who share the same athletic stature, towering over six feet. They both have the same twinkling eyes, and when shaking someone's hand, they grasp it like the business end of a bat. They are 75 and 73 years old.

The first major league baseball game Milt, the older brother, ever saw was the first one he played in with the Boston Red Sox in 1952. A recent graduate of Spring Hill College and member of the ROTC when the Red Sox expressed interest, he asked to be released from the ROTC and offered to return the signing bonus stipend. While surely charmed by the offer, the ROTC gamely gave their blessing and Milt was soon on his way to Boston. He became one of the best fielding shortstops of the 1950s.

Frank, the younger brother, who would go on to great prominence with the Atlanta Braves, began his career with the Detroit Tigers and was elected their MVP in 1958. Throughout his career, he never played an inning at any position other than second base and was known as the best pivot man in the league on double plays. Upon his retirement from Atlanta in 1967, he taught everything he knew to his replacement, Woody Woodward. As a credit to Frank's character, Woody remembered the grace in which Frank had so gallantly turned over the reins, and gave the same courtesy to his own replacement several years later.

Today, the brothers hold conversations with animated hands, playing catch with their memories. Frank talks of his young wife watching him from the grandstands, their three children in tow; while Milt remembers nursing his hand that was injured by the spikes of his brother playing on the opposing team, who had barreled into him to break up a double play. Milt was probably ruefully graceful about this, as, when children, he used to beat Frank up. When Frank grew, matching his brother in size, Milt formally reacquainted himself with a

handshake. The brothers described how their mother would confuse the crowd around her as she cheered for both teams when her sons met each other on the diamond.

During the winter season, when the brothers were not barnstorming in Mexico or taking odd jobs they would play in Eddie Stanky's pick-up games between both white and black players such as Willie McCovey, Hank Aaron, and Satchel Paige. Contemporaries, brothers, and Mobilians all.

Frank described how fame had followed him across time; he has boxes that hold the outpouring of fan mail received throughout the years, some as recent as the week before. There was a request from a Vietnam veteran for an autograph upon a tattered baseball card the soldier had carried with him throughout the war. There were letters expressing admiration and some proposing marriage. It was sentiment preserved, consisting of sheets of lined paper, most written over 40 years ago. And he had answered every one.

Upon the walls of their homes, there are photographs of friends: Mickey Mantle, Hank Aaron, and Sandy Koufax, who Frank hit a grand slam homerun off of in 1965 in the last game the Braves played in Milwaukee. But more prominently displayed are pictures of children, anniversaries, and birthdays. Lives well lived, both publicly and privately.

Once retired from the professional arena, the brothers returned home to Mobile. Frank became a creative architect and an inductee in the Alabama State Hall of Fame, as well as an instrumental mentor in the creation of both the Spring Hill College Hall of Fame and Mobile Sports Hall of Fame. In 1969, the brothers organized Major League Baseball Day in Mobile, complete with a parade in which the honored players rode in floats. Frank retired from his post at the United Way in 1994 where he had the opportunity to help create the Adaptive Baseball League for mentally and physically challenged youth. Ever loyal and proud of his hometown, during an ESPN interview, Frank challenged any other United States city to field an all-star team with talent as great as Mobile's. To this day, there have been no takers.

Milt continued to work with the Boston Red Sox, scouting new talent for the club. The brothers discussed the nuances of the selection process: they looked for the hustle of the players, the unburnished talent that counts for plays, and the heart that counts for passion; seeing how a player handled himself on a bad day was far more impressive than a stellar day on the diamond; and, most importantly, they looked for appreciation for the opportunity to play the game. Milt retired in 1995 from same organization he had first gone to work for 40 years earlier.

Once card-carrying members of Hartwell Field's "Knothole Gang," the brothers now have another title to their credit. In 1997, Bolling Brothers Boulevard, the road that leads to the gates of Hank Aaron Stadium, was ceremoniously unveiled in honor of the brother's achievements. It is where the difference between celebrity and distinction is a grand slam and where only the scoreboard steals the show.

A Bolling Tradition. Frank and Milt's uncle Jack was a major leaguer in his own right; he played with the Philadelphia Phillies in 1939 and with the Brooklyn Dodgers in 1944, where he batted .351 in 131 at bats. Prior to going to Brooklyn, Jack played with the Mobile Bears (pictured here). (Courtesy of Buck Williams.)

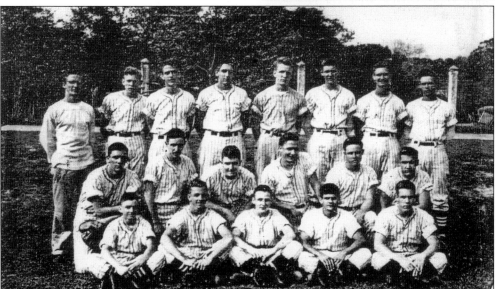

McGill-Toolen High School Team, 1947. While the Mobile Bears were winning their way toward a Southern Association championship, a few miles down the road at McGill-Toolen High School, some of the players on the Yellow Jacket ball team were getting ready to jump into the pros. Pictured here are Donnie Wagner (bottom row, first on the left), Frank Bolling (bottom row, third from the left), and Milt Bolling (top row, third from the left). (Courtesy of Donnie Wagner.)

MILT BOLLING

shortstop **BOSTON RED SOX**

MILTON JOSEPH BOLLING III. "Milt went on the voluntary retired list in January of 1952 to gain his college degree. He then returned to finish the season with Birmingham and the Red Sox. After playing the '48 and '49 seasons at Roanoke, Milt hit .288 and .253 for Scranton in '50 and '51. Milt, who coaches at a playground during the winter, was the shortstop on the Piedmont League All-Star team in '49"—*1953 Topps Baseball Trading Card.* (Courtesy of Milt Bolling.)

MAKING THE PIVOT. One of the best second basemen of his time, Frank Bolling made the American League All-Star team in 1961 and 1962 and won the American League Second Base Gold-Glove in 1958. Over 35 years ago, Frank, along with the rest of the Milwaukee Braves, were getting ready to pack and move to Atlanta, but before the team left County Stadium for the last time, they had to face the Dodgers and Sandy Koufax. Frank hit a rare grand slam off of Koufax in the losing effort. Frank had never seen himself play on television before until recently when his children gave him a videotape. On the tape was a documentary about the Milwaukee Braves featuring his grand slam. (Courtesy of Frank Bolling.)

At Ease. At 6 feet 1 inch, a trim Frank Bolling leans against the strong wrist he depended on for his powerful hitting ability. A standout in the Braves lineup, Frank retains fond memories of his time in Milwaukee and Atlanta and of his teammates, including the man whose locker was next to his, Henry Aaron. (Courtesy of Frank Bolling.)

Milt with the Red Sox. Most of Milt's career was spent in Fenway Park with the Boston Red Sox. During his seven-year career, not only with Boston, but also Washington and later as shortstop alongside brother Frank in Detroit, Milt compiled a career batting average of .241 with 19 homeruns. Milt jokingly quips, "In my first game I batted 1.000, going 1 for 1 with a walk. I should have stopped there." (Courtesy of Milt Bolling.)

TAGGING OUT "THE MICK" Not many ball players could catch Mickey Mantle on the base paths, but this wire service photo, aptly titled, "Too Fast for Mickey," shows Frank Bolling doing just that. It was only the second time in 13 games that "The Mick" was caught trying to steal second base that season. (Courtesy of Frank Bolling.)

HEY, GOOD LOOKIN'. Affectionately known as the "Rock Hudson of Baseball" for his dashing good looks, Milt Bolling smiles for a publicity photo. (Courtesy of Frank Bolling.)

Ed **BAILEY** 1964 Frank **BOLLING** 1961 - 1965 Denis **MENKE** 1962 - 1965

THEY NEVER FORGET. Over 20 years after playing their last game at County Stadium in Milwaukee, fans still flock to conventions and card signings featuring players from the Milwaukee Braves. Pictured is a recently issued print from the Claremont Sportscard and Memorabilia Show in Milwaukee featuring 5 time National League All-Star Ed Bailey, 2 time National League All-Star Denis Menke, and Mobile's Frank Bolling. (Courtesy of Author's Collection)

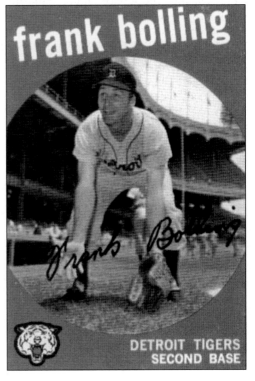

frank bolling

DETROIT TIGERS
SECOND BASE

WHY IS THIS MAN SMILING? Frank Bolling is all smiles in this photo of him with the Detroit Tigers in 1959 for this Topps' Baseball Card. Frank was in the top 10 for being hit by a pitch in the American League in 1959, tied with Washington's Harmon Killebrew and Chicago White Sox Nellie Fox with seven. (Courtesy of Author's Collection)

STREET OF DREAMS. Frank Bolling and brother Milt stand beneath the street sign bearing their name. In honor of the brothers' baseball and community contributions, the designation, unveiled in 1997, was in conjunction with the opening of Mobile's newest sports venue, Hank Aaron Stadium. (Courtesy of Frank Bolling.)

FIVE

Henry "Hammerin' Hank" Aaron

It is credited to the heat of a sultry Mobile summer night that one of baseball's greatest champions came into being. It is akin to how a legend rises, just as a moon clears the tree line of moss-draped oaks.

Summer 1952: it was too hot to go to bed. So Edward Scott, a part-time scout with the Indianapolis Clowns and former Norfolk All-Star player, kissed his wife goodbye and went out into the night to catch a local fast-pitch softball game. Watching from the stands, he noticed a 17-year-old Henry Aaron, playing third base and hitting like crazy. Ed's attention was captured not only by the hitting ability, but also by the odd way the young swinger gripped the bat with crisscrossed hands. As Henry ran past, Ed asked if he played baseball. He nodded. Ed invited him to come out and play for a semi-pro team, the Athletics, in the nearby city of Prichard, a suburb of Mobile. With the promise of a uniform sealed, Aaron agreed. First, however, Ed Scott needed to secure permission from Henry's mother. She refused. But Mr. Scott, armed with both charm and tenacity, went back the next weekend, and the weekend after that. Ultimately, it was his father, Herbert, who brought Henry to the ball field to don the uniform that awaited him.

Not long afterwards, Ed signed Henry to his first contract with the Indianapolis Clowns for $200 per month. Leaving home for the first time in his young life, Henry arrived at the train station the day of his departure carrying a small satchel containing, "two pairs of pants, two dollars, and two sandwiches." After putting him on the train, Ed entrusted Henry with a sealed note to be delivered to the Clowns manager upon his arrival. It read: "Forget everything about this kid, just watch his hit."

Henry received only one paycheck (and a suit) before he was sold to the Boston Braves for $10,000. From there, he was sent to play for the Class C team in Eau Claire, Wisconsin, and from there he went to the Jacksonville, Florida, franchise, becoming the first African-American player in the South Atlantic League. He was later named MVP. The last player of the Negro League to make it into the majors, Henry made his pro debut with the Milwaukee Braves in

1954, later moving with them to Atlanta in 1966. A teenager who once told his father he would one day play against Jackie Robinson—the man who had inspired Henry to believe that he too could make it into the major leagues—did so in an exhibition game between the Braves and Dodgers at Hartwell Field in 1954. Henry was named the National League's MVP in 1957 and was made captain of his team in 1969.

Henry played in relative anonymity for years. Though largely unnoticed, he was, however, recognized for his unwavering consistency and steadiness when he stepped up to the plate. Though he described his playing ability as "nothing fancy," everyone else saw otherwise. Through the years, Henry quietly went to work, and with even precision, was gradually closing in on the record of 714 home runs set by Babe Ruth in 1935. The closer he came to breaking baseball's most coveted record, the more attention he garnered, bringing him out of obscurity and into the glare of the limelight. "Henry" became "Hammerin' Hank" and every time he stepped up to bat, the nation paused to watch. But not all of the recognition was welcomed. Henry received vicious hate mail and death threats as he approached the record, about which he took the sage advice of his mother Estella: "Don't worry about that which you have no control over." Henry himself said of the mounting interest and pervasive media circus, "Roger Maris lost his hair the season he hit 64. I still have my hair, but when this is over, I'm going home to Mobile to fish for a long time."

On April 8, 1974, Henry Louis Aaron hit his 715th homerun, breaking Babe Ruth's major league record. Edward Scott was invited to attend the record-breaking achievement, but it was Henry's mother who was the first to greet him at home plate with outstretched arms. Upon his retirement in 1976, he had earned 755 homeruns, three Golden Gloves, and the All-Time RBI Leader title. Aaron, the 24-time All Star, was inducted into the Baseball Hall of Fame in 1982. In 1989, he was named senior vice-president and assistant to the president of the Atlanta Braves.

Ed Scott continued to scout talent, working for the Boston Red Sox from 1961 until his retirement in 1990. These days, he is likely found on a golf course, which is both poetically and historically significant. Mr. Scott, along with his friend, Nathaniel Wilson, was responsible for the inclusion of African Americans play on public golf courses in the city of Mobile. Encouraged by a high-ranking government official in 1959, the gentlemen brought a racial discrimination suit for equal play against the municipal city courses and won.

Several members of Mr. Aaron's family remain in Mobile and he is a frequent visitor to the city for both personal and civic occasions. Mobile has honored their native son with the naming of Hank Aaron Loop, Hank Aaron Stadium, and Hank Aaron Park in Toulminville (formerly known as Carver Park where Henry once batted bottle caps with broomsticks, in the stead of a bat and ball). All dedications to a man who left Mobile with two dollars in his pocket and returned the king of the world.

To the incredible talent that has come out of Mobile, pitching great Dizzy Dean once asked Hank Aaron, "What y'all got going in Mobile?" Hank answered with a shrug and a smile, "Guess it's in the water."

Not to mention the hot summer nights.

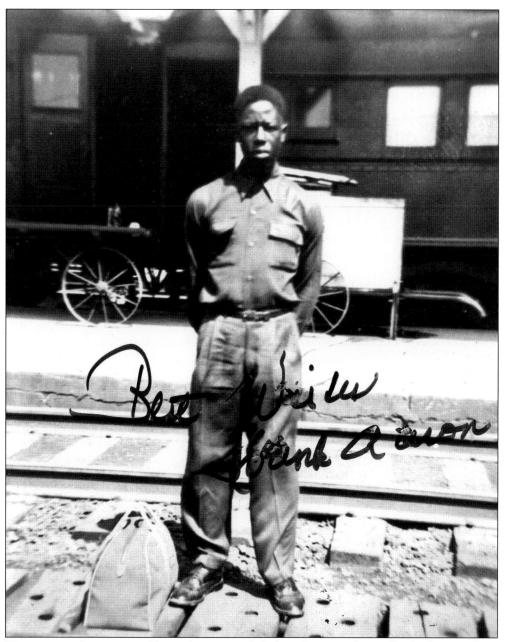

HISTORY AT SEVENTEEN. Henry Aaron stands before the train that will take him to glory. Newly signed to play for the Indianapolis Clowns at the age of seventeen, there was no way he could know that he would forever change history. All that he had prepared for is translated into what lies in that suitcase at his feet. Besides "two pants, two dollars, and two sandwiches," there was a glove and a ball tucked inside. Ultimately, all he needed turned out to be within him the entire time. (Courtesy of Edward Scott.)

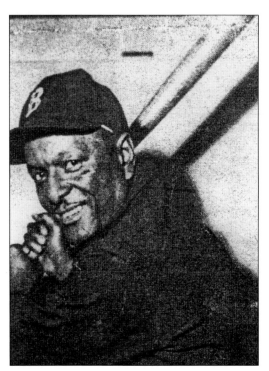

HISTORY MAKER. Edward Scott, the part-time Indianapolis Clowns scout who discovered Henry Aaron in 1952, once played for the Norfolk Stars and Mobile Black Shippers. Consumed by the love of the game, Mr. Scott eventually retired from baseball with the Boston Red Sox, where he was employed as a scout for many years. (Courtesy of Edward Scott.)

20/20 HINDSIGHT. Confident of the talent he had discovered in Henry Aaron, scout Ed Scott sent a letter to Brooklyn Dodgers general manager Branch Rickey, apprising him of the talent of the young up and comer. Mr. Scott received this letter of acknowledgement and thanks shortly thereafter. (Courtesy of Edward Scott.)

PITTSBURGH · BASE · BALL · CLUB
MINOR LEAGUE SYSTEM
May 23, 1952

Mr. Edward Scott
472 E. Ridge Road
Mobile, Alabama

Dear Mr. Scott:

 This will acknowledge your letter of May 21, 1952, addressed to Mr. Branch Rickey regarding Henry Aaron, 17 years old, 170 lbs., 5' 11". We will send the contents of your letter to our scout in that area who will endeavor to see him play.

 Mr. Rickey wishes to thank you for having thought of him.

 Very truly yours,

 George Sisler
 Supervisor of Scouts

MEDIA DARLING. Sports heroes are treated like celebrities and as such, have always been recruited by companies to help sell their products. This advertisement, taken from the pages of *Life* magazine, showcases a young Henry Aaron endorsing a product once widely accepted (even glamorized), but that is now considered both unhealthy and politically incorrect. (Courtesy of Patty Sayre.)

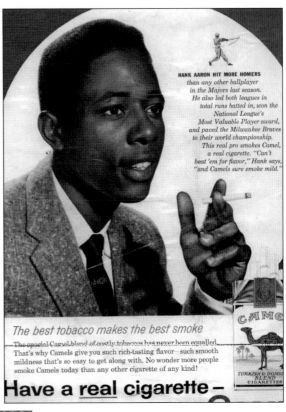

HANK AARON HIT MORE HOMERS
than any other ballplayer
in the Majors last season.
He also led both leagues in
total runs batted in, won the
National League's
Most Valuable Player award,
and paced the Milwaukee Braves
to their world championship.
This real pro smokes Camel,
a real cigarette. "Can't
beat 'em for flavor," Hank says,
"and Camels sure smoke mild."

The best tobacco makes the best smoke

The special Camel blend of costly tobaccos has never been equalled. That's why Camels give you such rich-tasting flavor—such smooth mildness that's so easy to get along with. No wonder more people smoke Camels today than any other cigarette of any kind!

Have a real cigarette—

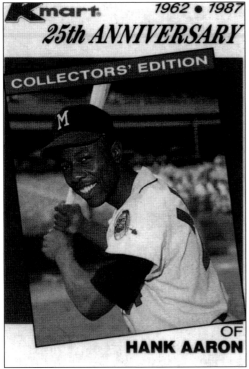

KMART GETS INTO THE ACT. In the early 1980s, Kmart decided to market their own series of baseball trading cards. In cooperation with Topps, most of the series were overproduced and of little value. However, some are standouts, including anything with Hank Aaron on them, such as this special "Collector's Edition" card. (Courtesy of Author's Collection.)

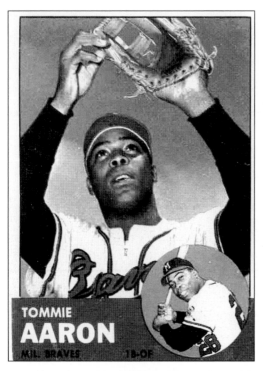

TOMMIE AARON. Henry's younger brother Tommie held his own on the baseball fields of the major league. Once a player, and later coach for the Braves, Tommie was half of the Aaron combination that hit the most home runs. Far too young, Tommie passed away of leukemia at the age of 45. (Courtesy of Author's Collection.)

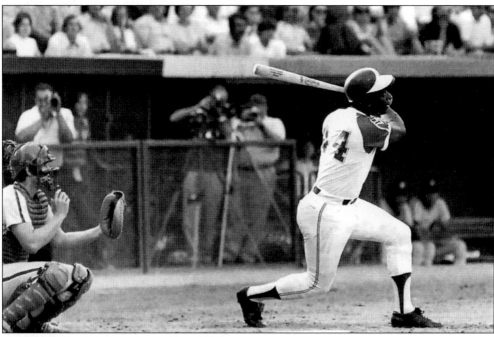

"IT'S 715!" On April 8, 1973, Henry Aaron went into the record books as the undisputed homerun king. But that is not the only record that landed him into the Hall of Fame. Before retiring, he set the record for hitting in the most runs (2,297) and the most number of extra base hits (1,477). He is the only player to hit 30 homeruns in 15 seasons and is the first player to reach 3,000 hits with 500 homeruns. (Courtesy of Author's Collection.)

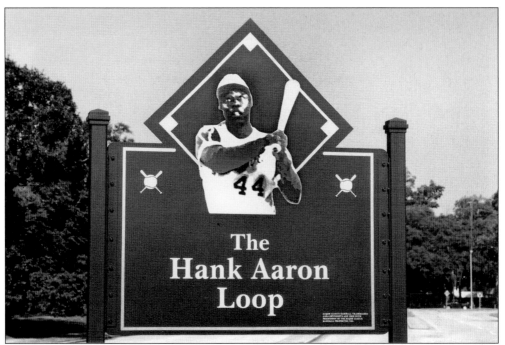

ROAD OF GLORY. A permanent dedication to Hank Aaron, the "Hank Aaron Loop," encircles the city of Mobile. The circuit follows Water Street along the historic waterfront, past the grand architecture of the GM&O Railway Station, Mobile's Cooper Riverside Park, and the Mobile Convention Center, and then loops back around to Broad Street and the rich Historic District. (Courtesy of Author's Collection.)

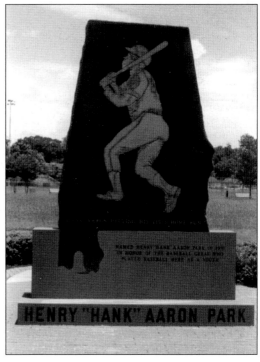

MONUMENTS TO GREATNESS. Standing in what was once known as Carver Park, a tribute to the guardians of local fame arises in Toulminville. Recently rededicated as Hank Aaron Park, the centerpiece features a granite monument in the shape of the state of Alabama. Encircled around the base are engraved marble slabs honoring the great baseball legends of Mobile, such as "Double Duty" Radcliffe, the Bolling Brothers, Pete Milne, Bill Adair, Stan Galle, Satchel Paige, and Bobby Robinson. (Courtesy of Author's Collection.)

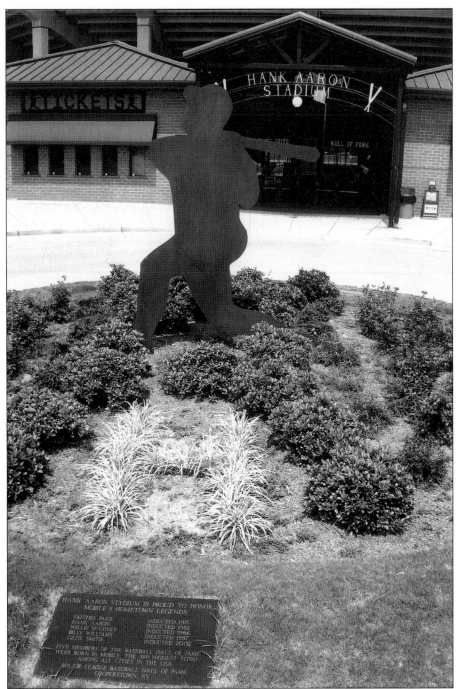

NO GREATER TRIBUTE TO THE GREATEST. In 1997, as the city of Mobile geared up for its return to baseball glory, the name for the new stadium was a no-brainer. The new facility, located just off of Interstate 10, would be known as "Hank Aaron Stadium", or simply, "The Hank." The entire complex not only pays tribute to Hank Aaron, but other baseball greats from Mobile. The stadium is located at 755 Bolling Brothers Drive, and is accessible from Satchel Paige Drive. (Courtesy of Author's Collection.)

HOMECOMING. An eloquent Henry Aaron makes a moving speech before throwing out the first pitch to officially open Hank Aaron Stadium and the start of the Mobile BayBears. With the stadium filled to standing room only and the events locally televised, those watching were witness to the greatness of Mobile's past and the new beginning of baseball glory. (Courtesy of Mobile BayBears.)

GENTLEMEN ON THE INFIELD. On hand to deliver the first pitch of the 2002 BayBear season home opener, Hank Aaron and Ozzie Smith stand side by side. Smith and Aaron were in town for the Mobile Sports Hall of Fame inductees' reunion, which was part of Mobile's Tricentennial Celebration festivities. That same evening, Ozzie Smith's plaque for the Hank Aaron Stadium Hall of Fame Circle was unveiled. On July 28, 2002, in his first year of eligibility, Smith was inducted into the Sports Hall of Fame in Cooperstown, New York. (Courtesy of Chip English, Mobile BayBears.)

SIX

Baseball Passes through South Alabama

Strolling down the ancient Mobile street known as Old Shell Road on any spring Saturday brings a barrage of sights and sounds. The deep Parrish blue sky is broken by an occasional wisp of a cottony cloud, an early indication the city's renowned late afternoon thunderstorms will be once again brewing on schedule. The first thing you will see as you move farther west from University Boulevard is the traffic—streams of cars cascade into a parking lot that looks far too small to contain them all, many of them with insignias soap-painted on the windows. Alpha Theta Chi, Kappa Alpha Psi, Chi Omega. The Greeks are well represented today. The aroma of hot dogs and hamburgers barbecuing engulf you. Then you hear the music. It's faint at first, but soon very recognizable: "Look at them Jaguars, here come the Jaguars."

You are passing by the home of the perennial NCAA Sunbelt Conference powerhouse University of South Alabama Jaguars. They are about to hit the diamond for an afternoon of baseball. While they have never made it to the "big dance"—the final series of the College World Series—University of South Alabama is a dynasty unto themselves in college baseball and a breeding ground for future major league stars.

The tradition began in 1969 as the University of South Alabama, located just a short drive west of the state's oldest college, Spring Hill, began its baseball program. The team would be the Jaguars. Their leader was a former standout shortstop of the St. Louis Cardinals, Eddie Stanky. Stanky's former manager, Leo Durocher, said of "The Brat:" "[Stanky] blazes the intangibles. He can't run, he can't hit, and he can't throw. All he can do is beat you." He brought to the University of South Alabama the same zeal that he had brought to the field in St. Louis as a shortstop and manager. Stanky had a fondness for Mobile. When he came through as a pro, he would organize pick-up games between the great black and white players of the city, something unheard of at the time.

After 14 years of coaching at the University of South Alabama, Stanky had sent 43 players to the major leagues, among them, such notables as Dave Stapleton of the Boston Red Sox, Pat Putnam of the Texas Rangers, and Mike O'Berry of the Cincinnati Reds. Stanky retired from

coaching and remained in Mobile until his death. In a 1983 interview just after he announced his retirement, Stanky said that even considering his World Series appearances with St. Louis, being a part of one of the greatest last-to-first stories in baseball history, the "Miracle of Coogan's Bluff," and all of the accolades afforded him during his pro-career, coaching at the University of South Alabama would always be his crowning achievement.

Since his retirement, Stanky's legacy lives on through University of South Alabama coach Steve Kittrell, former Spring Hill coach and a former player of Stanky's at the University of South Alabama. Kittrell has maintained the level of excellence expected of the Jaguars and has helped mold many more famous players into major league stars. He has become one of the top 50 winningest coaches in college baseball with a record of 756-431 as he enters his twentieth year at the University of South Alabama. As with Eddie Stanky, Steve Kittrell continues to lead Jaguar players to the majors. In fact, University of South Alabama has become known as a continuous feeder to major league baseball. The list of players from the program that have gone to the majors is both long and impressive. Such names as Jon Lieber and Mike Mordacai top the list. One of Kittrell's best-known players is Luis Gonzalez, who is currently with the Arizona Diamondbacks.

Since its inception in 1969, the University of South Alabama has appeared in 20 NCAA post-season tournaments and ranks consistently in the college Top 25 national baseball polls. As they say around the country, "Baseball passes through South Alabama." The University of South Alabama, that is.

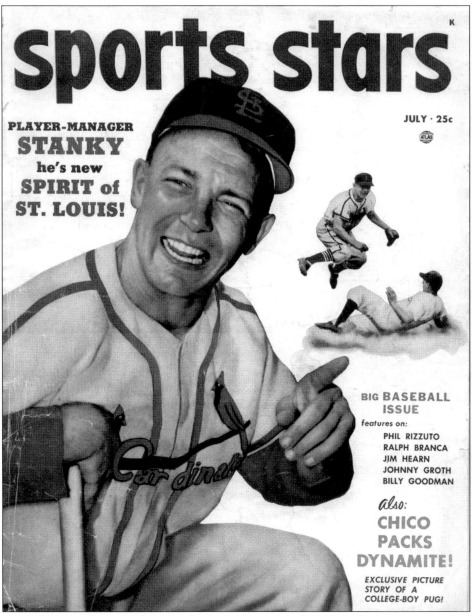

A TRUE "SPORTS STAR." Eddie Stanky, better known as "The Brat," brought a gutsy brand of baseball to the field both in his playing days and as manager with the University of South Alabama that few could master. He came from an era when the game was played for passion, not a paycheck, and winning meant the world, as evidenced by the intrepid play of Stanky and his teammates on the 1951 New York Giants team. After coming back from trailing their bitter rivals, the Brooklyn Dodgers, by 13.5 games, the National League championship was to be decided at the Polo Grounds in New York. The stadium was located below a rocky crag along the Harlem River known as Coogan's Bluff. On October 3, 1951, a true miracle happened at Coogan's Bluff when Giants' batter Bobby Thompson hit "The Shot Heard 'Round the World," and, well, you know the rest: "The Giants win the pennant!" (Courtesy of Author's Collection.)

THE BRAT'S NAMESAKE. Eddie Stanky stands before the brass plaque honoring and naming the home of the University of South Alabama Jaguars after him. The stadium opened on March 8, 1980, and the winning tradition began as the Jaguars swept a double header against the University of Alabama. Since that time, the field has hosted eight Sun Belt Conference tournaments. (Courtesy of University of South Alabama Media Relations.)

IN GOOD COMPANY. Even during retirement, Eddie Stanky returned to the University of South Alabama and his namesake stadium to pass along tips to up-and-comers. Here, Stanky takes to the mound with future major leaguer Jon Lieber. (Courtesy of University of South Alabama Media Relations.)

BOSTON'S MIKE O'BERRY.
Birmingham native and catcher
Mike O'Berry played for the
University of South Alabama from
1973 until 1975, making the All-
South Independent Team in 1975.
In a major league career that
spanned seven seasons, O'Berry
played for the Red Sox, Cubs,
Yankees, and Expos, hitting a
career 72 homeruns in 197 games.
(Courtesy of Boston Red Sox.)

**FREIGHT TRAIN ON THE BASE
PATHS.** Lance Johnson was a
speedster while he played with
the Jaguars; he holds the season
record for most stolen bases (89)
that remains standing today. After
playing for the University of South
Alabama, Johnson signed to play
with the St. Louis Cardinals. In a
major league career that spanned 14
seasons, Johnson also played on the
Chicago White Sox, Cubs, Yankees,
and Mets, where he made the
National League All-Star team in
1996. (Courtesy of University of
South Alabama Media Relations.)

FATHERLY ADVICE. A standout for Eddie Stanky's 1974 and 1975 Jaguars was Loxley, Alabama native Dave Stapleton. While with the University of South Alabama, the second baseman led the team with 89 hits, 25 doubles, and 69 RBIs during the 1975 season. Following the season, Stapleton signed on with the Boston Red Sox and eventually made his major league debut in 1980. (Courtesy of University of South Alabama Media Relations.)

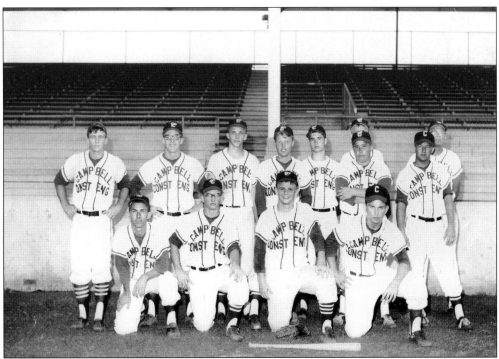

THE BEGINNING OF A CAREER. Pictured here is one of many 16-to-18–year old baseball teams in Mobile's "Connie Mack League." This is a photo of the Campbell Construction Company team taken at Hartwell Field. Coached by Ray Thurman (peaking around the corner, top right), the team featured two players of note—future University of South Alabama Jaguar coach Steve Kittrell (second from left kneeling) and his brother Mike (first on the left standing). (Courtesy of Ray Thurman.)

THE TRADITION CONTINUES. University of South Alabama Jaguar head coach Steve Kittrell had a hard act to follow to match the success of his predecessor and former coach Eddie Stanky, but he has done it in grand style. After over 20 years at the University of South Alabama, Kittrell is one of college baseball's winningest coaches, leading the Jaguars to 15 post-season appearances. While a player with Stanky's Jaguars, Kittrell batted .368, a club record which stands to this day. As Kittrell begins his 20th season, his record stands at 789 wins and 431 losses. During those years, his team has had only two losing seasons. (Courtesy of University of South Alabama Media Relations.)

TURNER WARD. Turner Ward made his professional debut with the Cleveland Indians on September 10, 1995, after roaming the outfield for the Jaguars during the 1986 season. This Saraland, Alabama, native has played on several teams in the major leagues and appeared in the 1999 National League Division Series with the Arizona Diamondbacks. (Courtesy of University of South Alabama Media Relations.)

DESTINED FOR STARDOM. South Alabama alumnus Luis Gonzalez was destined for the big leagues. Luis manned first base for the Jaguars between 1986 and 1988; he holds the record for scoring the most runs in a game (5) and the most RBIs during a season (80), and he made the All-American team in his freshman and junior years. His jersey number "5" was only the second Jaguar number to be retired. The other was Eddie Stanky's number 12. (Courtesy of University of South Alabama Media Relations.)

THE GREATEST SERIES EVER. After winning the first two games of the 2001 World Series, it looked as if the Arizona Diamondbacks were finished as the New York Yankees rallied to take the next three in a row. But Arizona would not take it lying down as they exploded in game 6 to beat the Yankees 15-2. Then, trailing the Yanks 2-1 in the ninth inning with two on, University of South Alabama alumnus Luis Gonzalez hit a game winning RBI single to clinch the championship for Arizona in what has been called "The Greatest World Series of All Time." (Courtesy of Arizona Diamondbacks.)

ACHT DU LIEBER! For two seasons (1991 and 1992), right-hander Jon Lieber pitched for Steve Kittrell's Jaguars, leading the team in victories in both seasons with identical 12-5 records, striking out 298 in the process and working up an ERA of 2.38. That was enough to impress the scouts; Lieber signed to play for the Pittsburgh Pirates in 1993 and made his professional debut in 1994. Currently, Lieber is a mainstay with the New York Yankees. (Courtesy of University of South Alabama Media Relations.)

COVERING GROUND. A shortstop from Birmingham, Alabama, Mike Mordecai came to play with the Jaguars in 1987 and quickly made a name for himself, leading the team in fielding and hitting. After setting the University of South Alabama record for the most base hits and RBIs in 1989 and stolen bases in 1988, Mike went on to play in the majors with the Atlanta Braves, appearing in both the 1997 and 1998 World Series. (Courtesy of University of South Alabama Media Relations.)

HEAT FROM "DOWN UNDER." In 1995, Mike Nakamura, from Victoria, Australia, set the Jaguar record for most saves in a season (12). During his stint at University of South Alabama from 1995 to 1997, Nakamura struck out 221 batters. He signed to play with the Minnesota Twins in 1997. (Courtesy of Vince Muzik.)

A MARLON IN TAMPA BAY. Marlon Anderson anchored second base for the Jaguars between 1993 and 1995. He signed with the Philadelphia Phillies in 1995, made his big-league debut in 1998, and stayed with the team until he was traded to the Tampa Bay Devil Rays in 2002. In 1995, Marlon led the Jaguars with 56 homeruns in 13 games. (Courtesy of Skipmilos.com.)

THE FIELD OF DREAMS. It is not hard to see why the University of South Alabama and Stanky Field have become known as a conduit to major league baseball. Stanky Field, named after the Jaguars's first coach Eddie Stanky, is literally a "field of dreams" with over 100 alumni signing professional contracts and 20 making the big show. Stanky Field also served as home to the Texas-Louisiana League's Mobile Bay Sharks in 1995 and 1996. (Courtesy of Author's Collection.)

INTO THE 21ST CENTURY. After 20-plus years of service and once being touted as the region's top collegiate facility, the University of South Alabama is working toward renovating old Stanky Field to bring it into the new century. Additional chair-back seating, upgraded concession and ticketing facilities, and ultra-modern press boxes are just a few of the proposed changes that will move the University of South Alabama program up another wrung on the baseball ladder. (Courtesy of University of South Alabama Media Relations.)

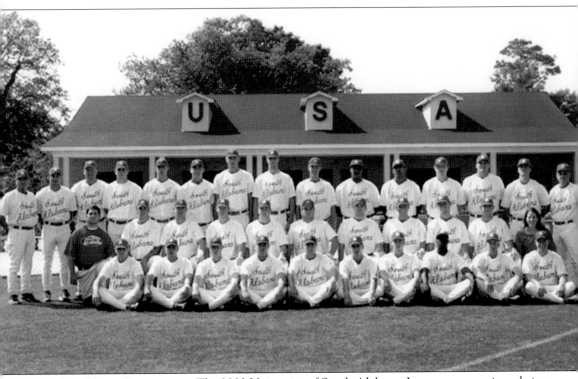

THE NEXT GENERATION. The 2003 University of South Alabama Jaguars once again rode into post-season play winning the Sun Belt Conference title and making it to the first round of the NCAA Regional tournament before being eliminated by Florida State. Pictured here in the official team photo are plenty of names to watch for in the future in the majors. From left to right - Top row: Assistant Coach Ronnie Powell, Volunteer Assistant Coach Tom Whitehurst, Assistant Coach Scot Sealy, Frank Elia, Bert Heath, Tony Neal, Caleb Crosby, Clark Girardeau, Ryan Mulhern, Tommie Major, J.J. Jackson, Adam Lind, Ryan Fillingim, Student Coach Josh Plaice and Head Coach Steve Kittrell. Middle row: Student Manager Jeremy Williams, Billy Fullam, Jansen Rayborn, Kevin E. Williams, John David Adams, Tim Land, Ben Nelson, Brett Parker, Adam Wood, Justin Hawaran, and Athletic Trainer Melanie Burke. Front Row: Ben Froemming, Josh Touchstone, Jason Gross, Cole Craig, Kevin Sytko, Wesley Love, Tyler Lynd, Kevin M. Williams, T.J. Touchstone and Kevin Laird. (Courtesy of USA Media Relations)

SEVEN

Hall of Fame Seasons
1962–1997

The images coming from the simulated wood grain television, though fuzzy, black, and white, were electric, and they stirred ancient passions in thousands of men and women who, a decade earlier, had their hearts ripped out when the Dodgers left Brooklyn. They vowed to never again give their hearts away to any other team once the Dodgers headed for the left coast, but in 1969 they could not help themselves. They found a new love to fill the void—the "Loveable Losers," the New York Mets.

For seven years, the Mets could barely muster a win, but on an October day in 1969, the television flickered with an image from Shea Stadium. One of the three "Mets from Mobile," Cleon Jones, clutched a high fly ball hit to left field: the third out. The "miracle" was complete. The Mets went from last to first and won it all, including the hearts of fans around the world.

Three Mobilians had helped the New York Mets become one of the sports world's most celebrated Cinderella stories: Cleon Jones in left field, Tommy Agee in center, and Amos Otis in right. Tommy Agee had a banner year with the Mets. It began with his first home run of the season at Shea, which hit the stadium's upper deck, the first to ever do so. It was the first of 26 homeruns for Agee during the season. Cleon Jones began his career with the Mets in 1963 and remained with the team until 1973. He was one of the few players who batted right-handed, but threw left-handed. He set numerous team season records while with the Mets including home runs, triples, and doubles. Amos Otis joined the Mets in 1967. Following the 1969 season, he was traded to Kansas City where his career blossomed, winning three Gold-Glove Awards and appearing in five all-star teams.

As the summer of 1969 began to wind down and the Mets were hurtling towards immortality, they found themselves in a battle with another team that was hungry for a world championship, the Chicago Cubs, who had not seen the inside of a World Series since 1908. While the Mobile Mets were patrolling the outfield at Shea trying to catch the Cubs, another Mobile native and future Hall of Fame player was hoping to make it to the big show with the Cubs, Billy Williams.

"Sweet Swingin'" Billy was destined for the Hall of Fame. During his 23-year career, Billy quietly went about his business, setting and breaking records such as the National League record for most consecutive games played, 1,117, later broken by Steve Garvey. He also tied the record for hitting five home runs in two consecutive games and for hitting four consecutive doubles in one game.

While the "Miracle Mets" were performing their magic, the fountain back on the Gulf Coast that had spawned some of baseball's greatest names appeared to have dried up. Following the 1961 season, the Southern League disbanded the Mobile Bears and the prospects of getting another team seemed slight. This changed briefly in 1966 as the Birmingham Barons dropped out of the league and famed baseball owner Charlie Finley moved his minor league team to Mobile to be called the Mobile Athletics. Baseball would be played once again at Hartwell Field. Although only in existence for a single season, the team was impressive, finishing first in the league with a record of 88 wins, 52 losses, 9 games ahead of second place Asheville, and 20 games ahead of everyone else. Despite the championship season of the Mobile Athletics, Finley relocated the team to Birmingham the following year, once again leaving an empty Hartwell Field until the summer of 1970.

As if spurred on by the Mets the year earlier, the Southern League expanded to eight teams and again allowed a team to play in Mobile, this time a farm team of the Chicago White Sox called the Mobile White Sox. This team did not have the power and flair of the Athletics four years prior. On the contrary, the White Sox languished at the bottom of the standings with a record of 59-79. Combined with poor attendance of only 35,000 the entire season, the beginning of the 1971 season found the Port City once again without a team. This time, it would remain that way for more than 20 years.

In 1979, Hurricane Frederick barreled through the Port City, uprooting Mobile's way of life and severely damaging the cornerstone of Mobile baseball, Hartwell Field. Champion of returning Mobile to its former baseball glory, retired major league star Frank Bolling went on a campaign to try and persuade the city council to rebuild the stadium. Sadly, his petition fell on deaf ears and on April 12, 1983, Hartwell Field was torn down for good, leaving only a vacant lot of broken cement and glorious memories of the past.

Despite the lack of minor league representation, Mobile still had a strong presence in the majors with one of its brightest stars, Henry "Hammerin' Hank" Aaron, the all-time homerun king. Another Hall of Famer of the era was Willie McCovey. From winning the Rookie of the Year Award in 1959 to his retirement in 1980, McCovey amassed amazing numbers. He appeared in six All-Star Games in his career, and in 1969, the National League All-Star outfield was all Mobile—Cleon Jones, Tommy Agee, and Willie McCovey.

And of course, lighting up the ballparks around the country was Ozzie Smith. Ozzie was pure entertainment with dazzling, gravity-defying catches and acrobatic back flips as he raced from the dugout to his position at shortstop for the St. Louis Cardinals. His world became known as "The Land of Oz," and Ozzie became the "Wizard," during the 1985 National League playoffs versus the Los Angeles Dodgers. Out of over 2,900 at bats, Smith had never hit a home run when he batted left-handed. That would all change in game five of the series. Bob Rubin of the *Miami Herald* wrote of the hit: "As if pushed by the roar of the crowd, a mystical, magical transformation took place in Busch Stadium. The ball yard by the Mississippi became the 'Land of Oz'." During his career, Ozzie broke Luis Aparicio's record for assists by a shortstop, won 13 straight Gold Gloves, and continued doing his back flips until he retired in 1996 and later claimed his rightful place in the Baseball Hall of Fame.

In 1990, at a time when cities across the country were clamoring to have their own minor league team to boost the economy with tourist trade and family entertainment, the Southern League decided to set down a strict set of guidelines for allowing a ball team to locate in a city. The rules were straightforward, but demanded a large investment from any city vying for a team. Such criteria as field dimensions, seating arrangements, even the brightness of lighting in each part of the field were set to strict tolerances. Due to the Southern League's edicts, several

independent leagues were formed around the country with cities such as Mobile looking to get back to their baseball roots.

Enter the Texas-Louisiana League.

The Texas-Louisiana League attempted to capture the essence of the Southern League by bringing family entertainment at affordable prices to these cities. Realizing that it would take winning teams to make the league float, league officials recruited some famous names in the game, such as Alan Ashby and Jose Cruz, to manage the teams. The Mobile franchise was piloted by former Boston star Ed Jurak. Teams either played in existing stadiums or rented fields from local colleges. The newly formed Mobile Bay Sharks entered into an agreement with the University of South Alabama and Stanky Field became the Bay Sharks new home.

But, by the fall of 1995, a new sheriff was about to hit town. Rumors spread that a new Mobile Bears-caliber team was heading to the Port City. That was enough for owners to pull the plug on the Bay Sharks after only two seasons. It appeared that once again, Mobile was destined to be without baseball. Little did fans realize at the time, but the rumors were true and the city was on a collision course to get back to its baseball greatness and the foundation Mobile legends were built on. A cradle of new baseball legends was about to be born.

1966

HARTWELL FIELD

SOUTHERN LEAGUE

MOBILE "A's"

SHORT LIVED, BUT SO GOOD. In 1966, a glimmer of hope was raised when famed Kansas City Athletic owner Charlie Finley made the announcement that his Birmingham team of the Southern League was relocating to Mobile to play at the then dormant Harwell Field. The team was spearheaded by players that would make up the nucleus of the World Champion Oakland Athletics team within the next few years. As a minor league team, they tore up the season, finishing 9 games ahead of the second place team, and 20 games ahead of the next nearest competition. The fickle Finley returned the team to Birmingham after only one season. (Courtesy of Chris Drago.)

HE WILL MANAGE. A former second baseman with the 1966 Mobile Athletics, Tony LaRussa is best known for his managerial record in the majors, managing the Chicago White Sox, Oakland Athletics, and St. Louis Cardinals. Most notably, LaRussa piloted the Athletics to the 1988 and 1990 American League championships and won the World Series in 1989. (Courtesy of Author's Collection.)

A PIECE OF A DYNASTY.
Affectionately known as "Gorilla,"
third baseman Sal Bando came to
Mobile as part of the Mobile Athletics,
Charlie Finley's Kansas City Athletics
farm team, in 1966. Bando lasted in
the minors about as long as the Mobile
Athletics lasted in the Port City,
leaving for Kansas City late in the
1966 season where he spent the next
11 seasons with the Athletics
organization, including the "dynasty"
of the three World Series
championships with the Oakland
Athletics in 1972, 1973, 1974.
(Courtesy of Author's Collection.)

NOT A MANIC MONDAY. Rick Monday played on the 1966 Mobile Athletics and went on to a phenomenal career in the majors with the Kansas City/ Oakland Athletics, Chicago Cubs, and Los Angeles Dodgers. Monday only hit one post-season home run in his career, but it could not have come at a better time. He hit the game-winning home run in the ninth inning of game five of the 1981 National League Championship Series; Monday's feat helped put the Dodgers in the World Series. Monday made national headlines when he thwarted a protestor who attempted to burn an American flag on the field of Dodger Stadium. Pictured here is a rarity from the Midwest: the top of an Isaly's Ice Cream Store Dixie Cup. Each top had a baseball player on it. This one featured Rick Monday. (Courtesy of Author's Collection.)

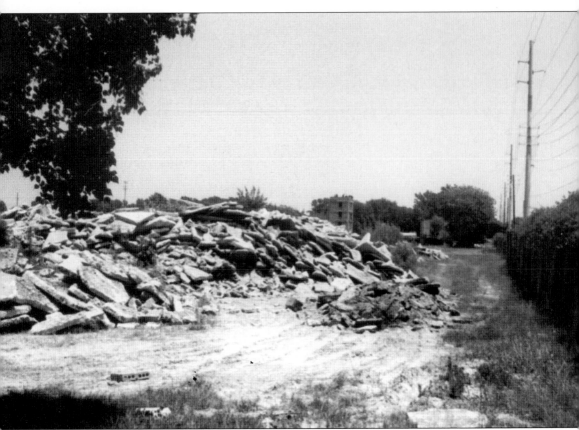

Hartwell is History. Once a grand bastion of baseball history, Hartwell Field was reduced to rubble in 1983. While the pulley factory where George "Shotgun" Shuba once hit homerun balls through the windows still stands across the lot on Ann Street, the Mobile City Police Mounted Unit is now housed on the former diamond. (Courtesy City of Mobile Archives.)

A STAPLE AT FENWAY. Former University of South Alabama alumnus and Fairhope, Alabama, native Dave Stapleton made his big league debut with the Boston Red Sox on May 30, 1980. Dave never left Fenway and played seven straight seasons with the Red Sox. During his career, Stapleton batted a career .271 and played just about every position on the field, except pitcher. He was with the Red Sox during the 1986 American League Championship Series against the California Angels when he went 2-3 hitting, and also appeared in the subsequent World Series versus the New York Mets. (Courtesy of Boston Red Sox.)

IMMORTALIZED ON VINYL. It wasn't Cleon Jones singing the Mets' theme song, but the entire 1969 "Miracle" season was recorded for posterity on vinyl as it was broadcast on radio and TV with Mets announcers Ralph Kiner, Bob Murphy, and Lindsey Nelson. (Courtesy of Author's Collection)

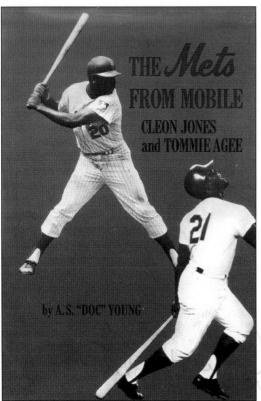

THE METS FROM MOBILE. The title of this 1970 book by A.S. Young sums it up quite nicely. Young traces the boyhood friendship of Cleon Jones and Tommie Agee in Mobile and how they came together to play for the 1969 World Champion New York Mets. (Courtesy of Chris Drago.)

ONE OF THOSE MOMENTS. Baseball fans around the world remember this scene as if it were yesterday: Cleon Jones gets the final out in game five of the 1969 World Series against the Baltimore Orioles officially making the team "The Miracle Mets." Moments after the catch, Jones and the rest of the Mets disappeared in a sea of 57,397 fans that poured onto the field to celebrate. (Courtesy of Author's Collection.)

A MIRACLE WORKER. The highlight of Tommie Agee's career came in game three of the 1969 World Series between the Mets and Baltimore Orioles. In what has been called "one of the greatest individual performances in World Series history," Agee began the game by hitting a first inning homerun off of Orioles' ace Jim Palmer. Then, in the fourth inning with two out and two runners on for the Orioles, Agee darted to the 396-foot mark in center field, making an impossible backhanded catch to end the inning (pictured here). Later in the game, Agee once again proved the impossible possible by making another head-over-heels diving catch to end the Oriole threat, saving the game for the Mets. (Courtesy of Author's Collection.)

THE MOBILE OUTFIELD. For a time in 1969, Mobilians manned the entire New York Mets outfield. Amos Otis completed the triad in right field. Later, Ron Swoboda took over the position when Otis was traded to Kansas City; that is where his career took off and he was voted to the American League All-Star team five times and won the American League Outfielder Gold Glove in 1971, 1973, and 1974. Otis played with the Royals for 14 seasons before retiring with the Pittsburgh Pirates in 1984. (Courtesy of Author's Collection.)

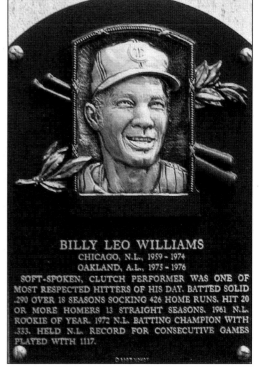

BILLY LEO WILLIAMS
CHICAGO, N.L., 1959 - 1974
OAKLAND, A.L., 1975 - 1976
SOFT-SPOKEN, CLUTCH PERFORMER WAS ONE OF MOST RESPECTED HITTERS OF HIS DAY. BATTED SOLID .290 OVER 18 SEASONS SOCKING 426 HOME RUNS. HIT 20 OR MORE HOMERS 13 STRAIGHT SEASONS. 1961 N.L. ROOKIE OF YEAR. 1972 N.L. BATTING CHAMPION WITH .333. HELD N.L. RECORD FOR CONSECUTIVE GAMES PLAYED WITH 1117.

"SWEET SWINGIN' BILLY." Billy Williams began his career in 1959 with the Chicago Cubs and spent the bulk of his 18 seasons in the big leagues at Wrigley Field. A six-time All-Star player, Williams ended his career with 2,711 hits, 426 homeruns, and a career .290 batting average. Today, Billy is still with the Cubs working in the front office. He was inducted into the Baseball Hall of Fame in 1987. (Courtesy of Author's Collection.)

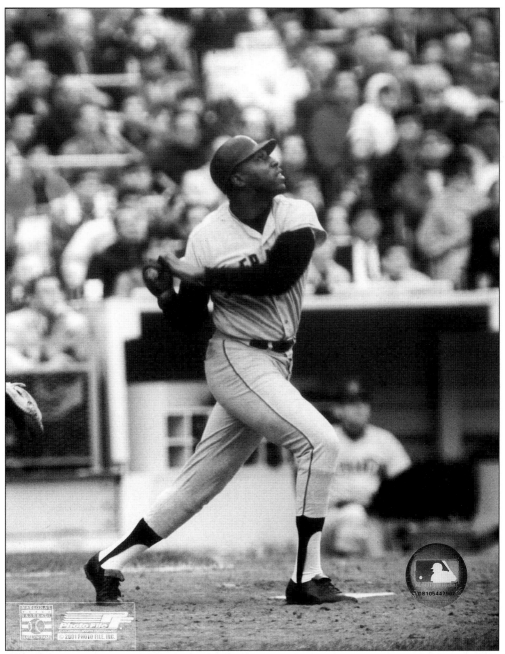

"STRETCH." Willie McCovey, also known as "Stretch," made it to the major leagues with the San Francisco Giants in 1959, sharing outfielding duties with another Alabama native and Hall of Famer, Willie Mays. McCovey's statistics ensured his enshrinement in Cooperstown, making six All-Star teams and hitting 521 career homeruns, a National League record for left-handed hitters that still stands. McCovey also became the first player to hit two homeruns in a single inning in two separate games and he hit three homeruns in both games of a double header against the New York Mets in 1969. (Courtesy of Author's Collection.)

THE "WIZARD OF OZ." The fifth Baseball Hall of Fame inductee from Mobile, Ozzie Smith was jazz in motion during his playing years with the St. Louis Cardinals. His gravity-defying acrobatics made him one of the greatest fielding shortstops in baseball history. Ozzie appeared in five league championship series and three World Series. (Courtesy of Author's Collection.)

LOCAL TALENT. From Montrose, Alabama, on the eastern shore of Mobile Bay, the Yelding family has produced a number of outstanding athletes. Eric was selected 19th by the Toronto Blue Jays in the first round of the 1984 free-agent draft and then selected by the Chicago Cubs in the 5-year draft before being signed by Houston and making his big league debut in April 1989. For the next five years, Eric played for the Astros, ripping up the base paths with 64 stolen bases in 1990. He finished his career in 1993 with the Cubs. (Courtesy of Eric Yelding.)

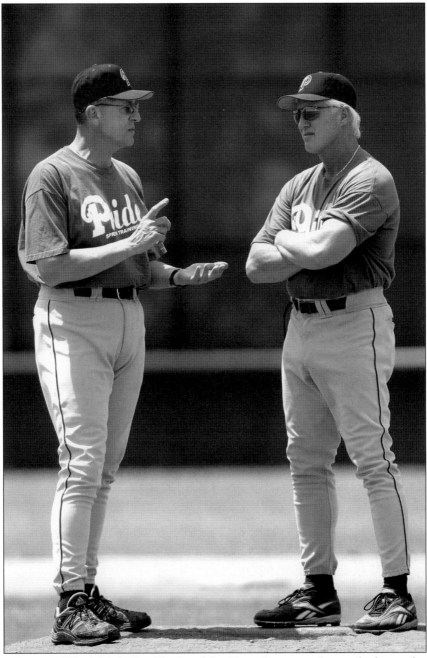

BUTCH HOBSON. The Mobile Bay Sharks of the Texas-Louisiana League had to replace their manager at the beginning of the second season. They turned to former Boston Red Sox player and manger Butch Hobson (pictured to the right). Beginning in 1975, Hobson played six seasons at third base with the Boston Red Sox. After retiring as a player, Hobson took over the managerial reigns of the Red Sox for the 1992 and 1993 seasons before heading to Mobile where he led the Bay Sharks to a 40-59 record and packed the stadium with fans. He also brought a "partial" working agreement for the Bay Sharks to be a developmental team for the Red Sox during his tenure in 1995. (Courtesy of Craig Amrosio/Nashua Pride.)

1994 INAUGURAL SEASON PROGRAM

BATTER UP! After 32 years without baseball, the city's interest in getting a new team and reassembling the legacy of the great Bears teams of the past peaked with the announcement that the Mobile Bay Sharks were coming to town. The team would be part of the newly formed Texas-Louisiana League, a league developed to allow cities that could support professional baseball a chance to get back into the game without the strict confines that were set down in the early 1990s by the Southern League. The team played at the University of South Alabama campus on Eddie Stanky Field and was highly successful in their two seasons of existence, with a combined attendance of 200,000 for the 1994 and 1995 seasons. (Courtesy of Author's Collection.)

BAYSHARK BUCKLEY. Born in Pascagoula, Mississippi, Terrell Buckley was a talented defensive back for the Florida State Seminoles, signing to play pro-football with the Green Bay Packers in 1992. Still in the NFL today, Terrell decided to use the summer of 1994 to try his hand at baseball, joining the Mobile BaySharks of the Texas-Louisiana League for a single season as an outfielder. (Courtesy of Florida State University Media Relations.)

EIGHT

The Mobile BayBears
1997–PRESENT

Even if you are not a fan of baseball, you have to admit there is a sort of romance to it. The aesthetics are sensual—the sweat of the players, the sweet crack of the bat, the deepening twilight kept at bay only by the crystal white infield lights. You can very well lose yourself in the diamond and time stands still. Mobile was lucky to have had Monroe Park and Hartwell Field in its past. Magical places where you held your breath with every pop fly and every foul ball brought children with baseball gloves clutched to their chests to the edge of their seats. And the girl who sold cotton candy was as familiar to you as a neighbor.

The institution of Mobile baseball resumed December 12, 1996. Thanks in part to Dr. Eric Margenau, the original BayBears owner, the Mobile City Council, Mayor Mike Dow, and private funding, ground was broken on Hank Aaron Stadium, the future home of the Mobile BayBears Professional Baseball Club, the San Diego Padres Minor League AA ball team relocated from Wilmington, North Carolina. Opening day at the park took place on April 17, 1997. Hank Aaron, the stadium's honored namesake, was on hand to throw out the ceremonial first pitch to a capacity-filled crowd of 6,000. The night was made sweeter still when the BayBears defeated their Southern League rivals, the Birmingham Barons, by a final score of 4-2. Later that night, the players of the inaugural team were found gathered around Mr. Aaron with baseballs and pens in hand. An ebullient team on opening night with Mobile's own undisputed home run king; there could have been no finer ending to the night and no more an auspicious beginning to the legacy of the BayBears.

Since then, Mobile baseball history has continued. During its first year in operation, the BayBears led the Southern League in attendance. In 1998, the BayBears were awarded the Southern League Championship and the Minor League Baseball Team of the Year. The team won 86 games that season and 13 players progressed to the majors. Since then, Hank Aaron Stadium has hosted three major league exhibition games between the BayBears and the San Diego Padres, the first of which ended a 30-year drought of major league action in Mobile. In

2001, the Mobile BayBears were selected as the Double A winner of the Bob Freitas Award, honoring the club's franchise stability, community involvement, and professionalism.

Thus far, a total of 45 BayBear alumni have gone on to the majors and one of the best accounts of the meteoric rise to the big time belongs to Jake Peavy. Jake was a high school pitching standout who first competed at the Hank in the 1999 High School Classic as a representative of St. Paul's Episcopal School. The San Diego Padres, duly impressed, drafted him later that year. In 2001, Jake returned to Mobile as a member of the BayBears lineup. During the winter season, Jake remained in Mobile and worked with the BayBears front office staff where he pitched in (no pun intended) with the daily behind-the-scenes responsibilities. Everything from calling on sponsors, to cleaning the ball field, to promotions and touring schools was included in his job description. In the first half of the 2002 season, Jake received the news that he had been promoted to major league prominence with the Padres. His first major league game, against the New York Yankees, was nationally televised and his BayBears family, teammates and office staff alike, held their breath watching one of their own as he struck out the great Derek Jeter. It has been described as one of the most poignant moments in BayBear history.

The BayBears have inducted an elite group of players into their self-proclaimed BayBear Hall of Fame. Members include Dusty Allen, recipient of the 1997 Community Service Award; Ben Davis, recipient of the 1998 Most Popular Player Award; Buddy Carlyle, 1998 BayBears Southern League Leader in Innings Pitched at 188.2; Matt Clement; Kevin Nicholson, co-recipient of the 1999 MVP; Brian Tollberg, the all-time BayBear strikeout leader with 15; Mike Darr; and Jake Peavy, 2002 Player of the Year. Not to be confused with the Mobile Sports Hall of Fame, Hank Aaron Stadium also pays homage to five native Mobilians with plaques commemorating baseball's most prolific players: Satchel Paige, Ozzie Smith, Henry Aaron, Willie McCovey, and Billy Williams. The inclusion of these five players, each inducted into the National Hall of Fame in Cooperstown, designates Mobile the third highest city in the nation with inductees.

Hank Aaron Stadium and the Mobile BayBears have contributed immeasurably to the community. In 1998, the creation of the BayBear Rookie Team was established "to provide and promote a positive sporting activity for all youths living within the Mobile and Prichard areas." One of the strongest displays of community impact, hundreds of inner city youths now participate in the program every summer. Each August, Hank Aaron Stadium hosts the annual Mark Harmon Celebrity Weekend benefiting Senior Citizens Services. The Hank Aaron High School Baseball Classic, highlighting local high school baseball teams; the Satchel Paige Invitational, an annual event featuring area independent schools; the Willie McCovey Challenge; and the Billy Williams Showdown, featuring local college teams, were formed to give local talent an arena in which to shine.

In an age when the family unit is becoming redefined, the BayBears offer the community not only an exceptional ball club, but also far ranging family entertainment. The BayBear mascots dance through the aisles and pop fly contests are held between innings. Little leaguers from neighboring towns collectively gather as the "Field of Dreams" teams when they take to the diamond pre-game for a moment of glory under the bright lights. On any given night, the stadium gives children t-shirts, bats, and baseballs, more than just promotional items, they represent a piece of Mobile's past, as well as what might one day become a part of their future.

The video board, in competition with the moon, frequently announces births, anniversaries, and special events as well as greetings to church groups, family reunions, and companies that have gathered for outings. Ceremonial first pitches are treated with pomp and circumstance for those in the community deserving of special recognition; for just a moment, the ceremonial pitcher gets to step on the pristinely combed mound and feel encircled by the sweeping view of the fans. Often, the pitcher is a child celebrating his fifth birthday at the stadium or an elderly gentleman celebrating his 90th.

The Mobile chapter of the Boy Scouts of America recently sponsored their first annual slumber party on the outfield. After the BayBears game, the stadium was turned over to the scouts until dawn. In succession, popcorn was served, "The Rookie" was played on the

centerfield fence, and curfew fell. In the dark, the tents must have glowed like stars dotting the field; with over 1,100 scouts and leaders in attendance, one can imagine it looked like nothing short of a fully formed constellation.

The ballpark offers everything Monroe Park and Hartwell Field of our past had and more. At the singing of the National Anthem, ball caps are placed solemnly over hearts. The players warm up in the outfield, making 90 mph catches look easy with a snap of the wrist, and the neon Krispy Kreme-green of the manicured grass is just as vivid. There is even a Ferris wheel on the park premises. However, there are marked differences: playing on the field are fully integrated teams and the minor league currently employs a female umpire. In 1947, Mobilians probably could have never imagined a 4,000 square foot state-of-the-art multi-use center featuring wireless technology and high-speed Internet access on the grounds of a ballpark like the Hank. Nor would they have been able to fathom the likes of Lynyrd Skynyrd. Homeruns notwithstanding, few things make the stadium erupt like the opening strains of "Sweet Home Alabama" played over the loudspeaker.

Yet from the opening pitch to the ballplayers shaking hands after the game, the timelessness of the game has remained in Mobile, even when time itself laid down for it. Mobile's fine baseball legacy has, at last, come full circle.

WHAT ELATION LOOKS LIKE. As winners of the 1998 Southern League Championship, teammates fall against one another in triumph, creating a pileup of celebratory proportions. It happened before a standing room only crowd on September 18, 1998, at Hank Aaron Stadium. The team ended the season with a record of 86-54 and attendance to see the team in their second season was upwards of 270,000. (Courtesy of Chip English, Mobile BayBears.)

SEEING STARS. With a wave to the fans, actor Mark Harmon strides off the field. The Mark Harmon and Friends celebrity game, held annually, pits local business and media celebrities against Mark Harmon's Bombers team. The exhibition game benefits Senior Citizen Services and has raised almost $250,000 during the years it has been hosted. It has also brought Hollywood glamour to the city. (Courtesy of Author's Collection.)

FAMILY ALBUM. Mobile's own Jake Peavy poses on the field with wife Katie and son Jake Jr. He played on the field as a teenager, as a BayBear, and would return, in later visits, as a Padre. One of many outstanding players to come from St. Paul's Episcopal High School in Mobile, Jake quickly made his mark upon joining San Diego in 2002, winning his first 6 out of 17 starts and striking out 90 in his first 97 innings. (Courtesy of Chip English, Mobile BayBears.)

DUNCAN MCADOO. A right-hander from Houston, Texas, Duncan McAdoo is quickly making a name for himself and rising up the ladder toward the majors. A graduate of the University of Houston, McAdoo was signed as a non-drafted free agent in 2000 and immediately went to work at the Padres Rookie League farm team in Idaho Falls, Iowa. (Courtesy of Author's Collection.)

HOMERUN STANDOUT. Gabe Alvarez is yet another example of Mobile as a springboard to the big leagues. Following the inaugural 1997 BayBear season, Gabe was catapulted to the major leagues during the 1998 an 1999 seasons before moving to the Padres in 2000. Gabe holds the BayBear record for the most homeruns hit in a single month; he hit nine in August of 1997. (Courtesy of Mobile BayBears.)

A CONNECTICUT YANKEE. Todd Donovon roams the outfield for the 2003 Mobile BayBears. Originally from East Lyme, Connecticut, Todd appeared in his first professional game with San Diego's Idaho Falls Padres of the Pioneer Rookie League. The Padres selected Donovon in the eighth round of the 1999 First Year Player Draft. (Courtesy of Author's Collection.)

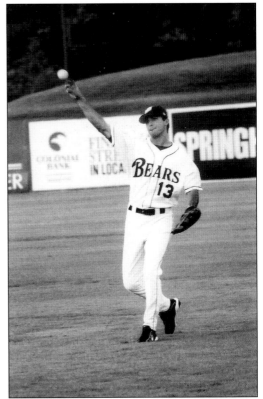

BAYBEAR OVERSEAS. Buddy Carlyle joined the BayBears in 1998 and quickly set the fledgling team record for most wins in a season at 14. After playing with San Diego for a brief time, Buddy became the first BayBear to play in Japan, joining the Hanshin Tigers in 2001. (Courtesy of Chip English, Mobile BayBears.)

BEST REASON TO STAY THROUGH A RAIN DELAY. Bill Shanahan, general manager of the BayBears, ensures that teamwork at Hank Aaron stadium is exemplified off the field as much as it is on. Following a rain delay, the staff lines up against the tarp covering the field, grabs it up in seamless unison and walks towards the outfield, thus slowly uncovering the diamond. In those fluid moments, the tarp billows up as the field is revealed and is often cause for the crowd to break into spontaneous applause. Poetry in motion and the game has not even begun. Teamwork is the BayBears' business and it shows. (Courtesy of Author's Collection.)

THE FIELD STANDS TO HONOR THE NATIONAL ANTHEM. This Southern League umpire crew boasts the only female umpire, Ria Cortesio (pictured third from left), currently in the minor league baseball system. Ria, the fifth female umpire in professional baseball history, is often found umpiring games at Hank Aaron Stadium throughout the season rotation. (Courtesy of Author's Collection.)

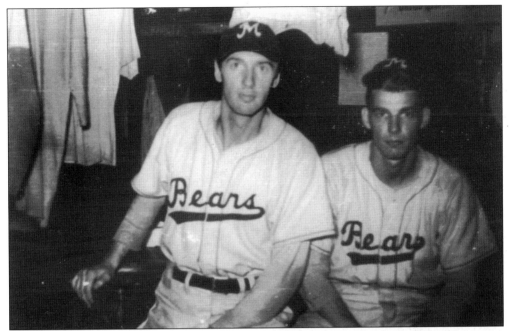

TIME TRAVEL. Taking us back to 1948, Mobile Bears' pitcher Frank Laga (right) strikes a pose with an unidentified Bears' player in the uniform honored by the Mobile BayBears during their annually held "Turn Back the Clock" day. The original Bears' uniform had a simple image of a black bear on the left side of the shirtfront. (Courtesy of Felice White.)

THEN AND NOW. Inspired by the original 1946 Mobile Bear uniforms, John Powers and Tim Cinces don the commemorative outfits for the BayBears annually held "Turn Back the Clock" day. Powers holds several BayBear records including most walks (163), most doubles (65, tied with Kevin Nicholson), and most hits (323). (Courtesy of Chip English, Mobile BayBears.)

ONE IN A MILLION. A batboy with the BayBears for the past five years, Wade Vadakin has a fan following of his own. Though born with congenital brain stem damage, Wade's vivacious spirit emerges during game time. His claim to fame is the "riding of the bat," a galloping run astride a baseball bat after each BayBear homerun. Wade was recently called to the majors for a one-day stint as the San Diego Padres batboy. There, he was reunited with former BayBear players Jake Peavy and on the Padres opposition, Ben Davis of the Seattle Mariners. (Courtesy of Author's Collection.)

BEAUTY AND THE BEARS. Several contestants of the America's Junior Miss Scholarship program take a respite with Beach Bear and Baby Bear during their visit to the Hank. As a part of their promotional tour, the girls played softball, greeted fans, and participated in throwing 50 simultaneous first pitches, the end result of which is currently a pending world record. (Courtesy of Chip English, Mobile BayBears.)

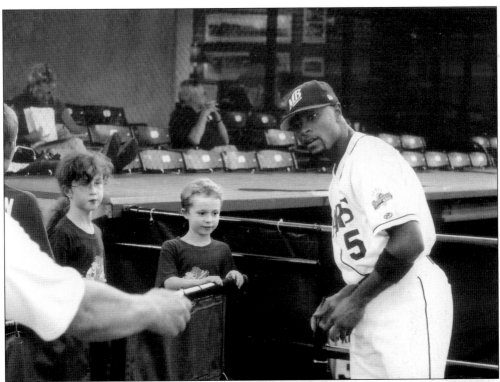

PUTTING IT DOWN FOR POSTERITY. One of the best things about being a kid is having a hero and one of the best things about a ballpark is having ready accessibility to them. BayBear second baseman Bobby Scales is happy to autograph baseballs for the kid in everyone. (Courtesy of Author's Collection.)

VIEW FROM THE DUGOUT. Watching the game that plays out before them, players wait their turn at bat and cheer on their teammates. Nowadays, stadiums are built to precise and exacting standards, but in 1958, when Hartwell Field was constructed, the dugouts were built so low that players had to duck their heads to maneuver about within. (Courtesy of Author's Collection.)

STEAL AWAY. Always dangerous on the base paths, outfielder Freddy Guzman takes a stroll off first only to steal second base seconds later. Guzman and Todd Donovan battled it out for the team season high for most stolen bases and were aiming to reach the top five base stealers in the Southern League in 2003. (Courtesy of Author's Collection.)

GOOD GAME. A tradition as reverential as the game of baseball itself, the handshake after the game represents more than sportsmanship; it represents the gentility, respect, and appreciation of a game well played. (Courtesy of Author's Collection.)

EPILOGUE. In the backyard of Mobile lies Hank Aaron stadium. Find your battered and outgrown catchers mitt and take in the luxury of a game day at the ballpark. There, you'll find businessmen with cell phones turned off and work abandoned, the rest of the day spent in the arms of the lush, sprawling field. The hot dogs are 50¢, and ceiling fans, unbidden, stir the breezes that swirl the red clay high into the stands. After the last base has been rounded, make your way down stairs littered with ticket stub confetti to the gift shop where $7 will buy a freshly retired BayBear baseball, scuffed and stained with red clay, hot off the field. It is our sincere hope that, as in baseball, you'll follow the rules: Start for home. And play ball. (Courtesy of Author's Collection.)

Joe Cuhaj is originally from Mahwah, New Jersey, where he and his friends in high school would often be found hitting the subways to the Bronx to catch the Yankees. Joe is a former radio broadcaster in the Port City and is currently a software programmer for a local company. (Courtesy of Author's Collection.)

Tamra Carraway-Hinckle, a Texas native, resides in Mobile with her husband and two dogs. Originally ignorant of the difference between an RBI and ERA, Mrs. Hinckle is now fluent in all manners of baseball terminology and scoring. This is her first book. (Courtesy of Author's Collection.)